20 Ways To Make Money In Photography

STAN HOLDEN

AMPHOTO
American Photographic Book Publishing Co., Inc.
Garden City, N.Y.

CONTENTS

Preface

If you're an amateur photographer, supporting your hobby can get pretty expensive. Prices for photo equipment, film, and photofinishing keep going up and up, with no end in sight.

If you're a professional or semi-professional photographer, you no doubt have problems, too. Perhaps you're not getting as much business as you'd like, or you have a lot of business but not enough profit, or your specialty is getting boring, or you don't have a specialty so you have nothing outstanding to offer potential clients.

Whether you're an amateur, semi-pro, or pro, this book can help. It can help you make anywhere from an extra $25 or $50 per week to as much as $500, or perhaps even more, for a few hours' work. It can help make photography more exciting for you, and it might even help make you famous.

Here are 20 different ways to make money in photography with a camera or via some other photo-related activity. You're probably familiar with many or all of them, but perhaps you haven't given them much consideration as a part-time or full-time way to make money. Yet, people *are* making money—sometimes a *lot* of money—following the techniques outlined in this book.

That's what this book is intended to be—an outline of money-making techniques. Don't expect detailed, step-by-step procedures. Instead, I've attempted to provide an overview of each specialty—what it involves and, briefly, how to do it—along with some basic information on the equipment required, the potential market, and typical prices. I've also included information on books and magazines to which you can refer and suppliers to whom you can write for further details, equipment, and/or supplies.

You can start reading this book by jumping in anywhere to any chapter that sounds interesting. Then read another, toward the front or toward the back. It doesn't matter in which order you read the chapters —because they're independent of one another—but try to read them all. You'll never know *which* technique might be best for *you* until you give them all some kind of consideration.

In most cases, it doesn't make much difference what kind of photographic experience you've had or what kind of photo equipment you own. If you're willing to take the time and effort to study a specific technique and practice it until you're proficient, you should be able to make *any* of the 20 techniques pay off for you. It may not even be necessary for you to purchase additional equipment.

So if *you* would like to make money in photography—or make *more* money than you're already making—select one or more of the specialties covered in this book and give it a try. Others are doing it, why not *you?*

4

1
Outdoor Portraits of Children

One of the nicest things about taking outdoor portraits of children is that you can get started with a bare minimum of both equipment and experience, and no matter how ordinary the result, some proud mother is usually willing to pay good money for it!

However, unlike most other fields of photography, better equipment and increased photographic knowledge do not always guarantee better photographs. The key to good child photography, especially outdoors, is knowing how to get along with your subject by knowing how to establish and maintain rapport.

That's why a person who loves kids but has only a simple camera can often produce outstanding child portraits, while a photographer who has everything but a fondness for children, often turns out technically excellent but otherwise disappointing work.

You can use almost any kind of camera for outdoor portraits of children—from a 110 Pocket Instamatic to an 8″ x 10″ view camera. For years the 2¼″ x 2¼″ single-lens reflex or twin-lens reflex was a favorite. It's still being used for this type of work (especially the single-lens reflex with interchangeable lenses), but most photographers today seem to prefer the 35mm SLR, or better yet, two of them. This permits you to use a standard (50mm) lens on one camera for full-length or group shots, and a short telephoto (100mm to 135mm) on the other for close-ups without distortion (or simply to help keep your subject from getting camera-shy). Also, when you load each camera with a 36-exposure roll of film, you can shoot up to 72 pictures before you have to stop and reload.

An exposure meter built into each camera and a lens shade on each lens are about the only other items you really need. (However, we'll mention others a bit later on.)

To get started in outdoor child photography, first see how others do it. Study appropriate photographs in such publications as *Parents'*

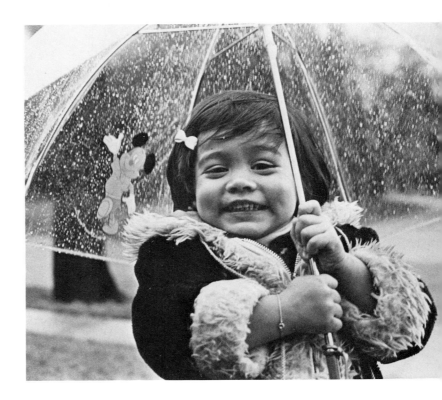

Don't let bad weather stop you. Try taking outdoor pictures of your children in the rain. Photo by Heber Marquez.

Magazine, *Redbook,* and *Modern Photography,* or in the show windows of any professional studio specializing in this field.

You'll soon discover that the best work has a unique charm about it—a far cry from the over-posed, over-lighted indoor portraits that far too many professional studios turn out. Study good outdoor portraits of children, and you'll see close-up and full-figure shots of youngsters staring out into space or flashing a genuine smile at the camera, climbing trees, sniffing flowers, playing with pets, whispering secrets in each other's ears, walking hand in hand along a forest path, holding a ball or a bat or a favorite toy, sitting on stone steps or a rail fence, climbing on playground equipment, pulling wagons, riding bikes or trikes, or just lying contentedly on the grass at peace with the world around them. Here are children as *children,* not as miniature adults dressed up in their Sunday best and posing stiffly in an environment which is alien to them.

After you've absorbed these photos, and perhaps clipped a few from the magazines for later reference, arrange to borrow a friend's or neighbor's youngster (any age from about two and a half to five is good) in exchange for some free photographs. Even if you have your own children in this age group, it's best to borrow somebody else's so you can get some practice working with non-relatives. These pictures will serve as good samples to show prospective customers.

Your little subject should be well rested, wear casual clothes, and not be afraid to get them dirty—and so should you. Both of you may end up flat on your stomachs in the grass, or up in a tree, and a little

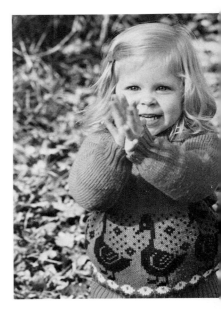

A game of catch can lead to semi-action shots like this one.

6

dirt shouldn't get in the way of good pictures. (It might help if your gadget bag contained a box of Wet Ones, a small towel, a comb and brush, a few Band-Aids, a pair of tweezers, some tape, and a small box of cookies. A compact ladder, stored in the back seat of your car, might come in handy, too.)

Your photo session should last no longer than 30 or 40 minutes, especially if the child is two or three. Otherwise, his patience and interest may disappear. Periodically moving to a new location within a park can help to hold his interest longer, but when he gets tired and cranky you might as well pack up and take him home. While the youngster's in a good mood, try to shoot as many different poses as you can get, from a variety of angles and distances, so you'll have a good selection to show later on.

Ideally, you should be shooting in the early morning or late afternoon, when the sun's rays are at an angle (the worst lighting occurs when the sun is directly overhead) or on a cloudy, bright day, when the light is pleasantly diffused. However, if you must shoot on a dull day, you can add highlights by means of a speedlight at the appropriate distance; attach it to a light stand and connect it to your camera with a long cord. Just don't overpower the natural light by placing it too close. If you prefer, try the relatively new (to most people) type of lighting control known as subtractive lighting. Using a black photographic umbrella or opaque screen (gobo) on a light stand, you block the natural light from one side of your model's face. This serves to increase the amount of light on the front of the face (by comparison) for a nice, soft lighting effect.

Other light-control techniques include the use of translucent materials or netting to diffuse the sunlight, lens filters to reduce contrast, and vignetters to diffuse the perimeter of your picture.

This unposed shot was snapped at a neighborhood park. Taken with a Nikkormat and a 35mm lens.

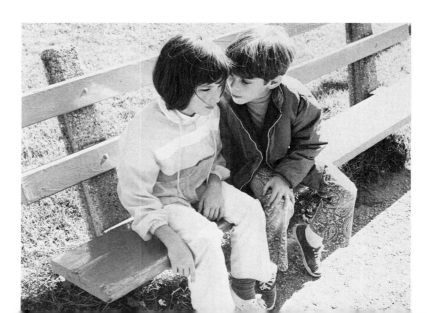

Whatever you do, try not to have your subject look directly into the sunlight. This will make him squint and may harm his eyes. Instead, you face into the sun, make sure your lens shade is long enough to prevent flare, and shoot. You can fill in the shadows if you wish, with a speedlight, a white or aluminum foil reflector, or simply expose for the shadows and let the highlights go white. Another alternative is to turn your subject and shoot with sidelighting, or take pictures in the shade of a tree or building (or in the shadow cast by a large opaque cloth stretched between two light stands).

Until you become an expert at outdoor child portraiture, you might be better off limiting yourself to black-and-white film only. Tri-X will give you plenty of speed, reasonably fine grain, and sufficient latitude for most situations. However, on a bright day it may be *too* fast, espe-

Amy's "chair," the base of a tree trunk, permitted both model and photographer to rest for a few minutes and have an opportunity to capture this appealing outdoor portrait.

Bring along a few toys, such as a large ball, for props. An assistant, preferably the child's mother or father, helps keep your model interested and active.

cially if your lens stops down only to $f/16$ and your shutter speeds are no faster than 1/250 sec., or if you want to shoot at a large lens opening (such as $f/5.6$) in order to throw the background nicely out of focus so it won't distract from your subject. It may be too grainy if you intend to enlarge some 35mm negatives—or sections of them—up to 16″ x 20″. So also consider using a medium-speed film such as Plus-X Pan.

No matter what film you use, and regardless of your camera, lens, and any other equipment you might bring, test everything out before going on location. Shoot a roll of film and develop it yourself, or send it to the same lab you plan to use later on (when you take pictures for paying customers), to make sure everything functions properly and that you're using the correct film speed.

After you've photographed two or three youngsters for practice, you should have enough good samples to show prospective customers. Your best negatives should be enlarged to 8″ x 10″, 11″ x 14″, or whatever size you plan to offer. If you plan to offer prints mounted on wood or Masonite, some of your samples should be mounted, too.

Next, the question arises, How much should you charge? If your work is good—*really* good—and your potential customers are fairly well-off, you can charge quite a bit! (Remember, you can always lower your price, but it's hard to raise it.)

For example, a young woman who specializes in outdoor child portraiture in Chicago and the northern suburbs charges $9 for a 5″ x 7″ enlargement ($14 if mounted on Masonite), $14 for an 8″ x 10″ ($24 mounted), $22 for an 11″ x 14″ ($34 mounted), and $32 for a 16″ x 20″ ($52 mounted). Her minimum order is $50, but her average order is between $150 and $200, and at least one order came to $600. Many of her customers order a set of prints for their home, another for the husband's office, and perhaps extra prints for relatives.

A typical order looks like this:

```
One mounted 5″ x 7″ print @ $14  ..................... .$14.00
Three mounted 8″ x 10″ prints @ $24 ....................  72.00
Two mounted 11″ x 14″ prints @ $34 ...................... 68.00
                                          Total: $154.00
```

She normally shoots two rolls of 36-exposure Tri-X per 40-minute session, has them developed with proof sheets, and then either makes the enlargements herself or has a custom lab make them for her. Either way, she does her own mounting.

Counting the time needed to line up the job and show samples (not always necessary), take the pictures, work in her own darkroom or deal with the lab, show proofs, and deliver the finished prints, the typical

assignment totals about five hours. Her expenses for the $154 job itemized above come to about $29 (including film, lab fees or darkroom expenses, mounting supplies, and gas for her car), leaving her a profit of $125—an average of $25 an hour! Naturally, she earns even more when the print order comes to $200 or $300.

How does she get her customers? She advertises in a local magazine (along with two or three competitors who work in a similar way), but much of her business comes as the result of the free exhibits she gets in local restaurants and movie theaters. (A neatly lettered sign supplies her name and phone number.) She also gets numerous referrals from satisfied customers, and repeat business—at intervals of three or four years—is common.

In case you think $14 for an 8″ x 10″ print is a little steep, you can charge two-thirds or one-half her prices and still make a decent profit handling six or eight assignments per weekend (as she does). Conversely, you can shoot only color and charge even more!

Magazines like *The Rangefinder,* for the professional photographer, are filled with ads offering color enlargements at low prices. For example, if you shoot Vericolor II or Kodacolor II negative color film, at least one lab will make an 11″ x 14″ color enlargement for only $5, and you can easily charge $15, $20, or even more for it. You'll also find ads on portrait folders, frames, and wood plaques at wholesale prices, and you can make a good profit on these, too.

Just in case you're far from a tree-filled backyard or park, it's still possible for you to handle outdoor portrait work by just looking around you. Those solid brick walls, apartment-building entrances or courtyards, schoolyards, or other city settings can make effective backgrounds with the proper choice of camera angle. Shoot with your lens wide open and throw everything out of focus but your subject.

As long as there are youngsters around, it's possible to make money—quite a bit of money—taking outdoor portraits of children.

2
Feature and News Photos for Newspapers

When you think of a news photographer, you think of a guy dashing around town taking pictures of fires, accidents, murders, celebrities, and sports events, right? Wrong, except for the sports events. Most of the work of a news photographer, especially those on small-town dailies or suburban weeklies, is pretty routine and often unexciting. That, indirectly, is why there's a way for you to make money taking photos for newspapers.

Let's forget, for the moment, the big-city dailies like the New York *Daily News* and the Chicago *Tribune*. According to *The Photography Catalog* (a very interesting, king-size book on equipment, techniques, and personalities), there are 50 photographers on the staff of the *News*. According to a phone call I just made to their assignment desk, the *Tribune* has 42 people on its photo staff, including 8 who work in the lab but occasionally shoot pictures. Therefore, except for spot news photos, neither of these papers—like most big dailies—is much of a market for the freelance. (For spot news photos they use, the *Tribune* pays $35–$50, and they may even pay $10 or $15 to a freelance if he calls in about a news photo he just shot, they tell him to bring it in, but it turns out they can't use it.)

The small-town dailies and suburban weeklies are a different story. Often, they're understaffed, and their few photographers can't be everywhere at once. Also, the majority of their photos are either news photos of scheduled events (the weekly city-council meeting, school activities, etc.) or feature photos (an afternoon at the senior-citizens center, potholes in the streets, a recently opened store, etc.). So there's a good chance that their chief photographer or picture editor is using, or looking for, a competent, dependable freelance to help out when the staffers are too busy with other assignments.

On Chicago's North Shore, for example, there is a chain of 10 suburban weekly newspapers, serving 10 adjacent communities, with

the five-man photographic staff working out of a centrally located headquarters building. Some of the photos appear in all 10 papers, but most of them are taken exclusively for specific papers, so the photo staff is kept busy. Each man covers an average of four or five assignments per day, and they work a 40-hour week.

Jerry Howard, the chief photographer, told me that he regularly uses a free-lance photographer (a former staffer) to cover sports "because he's very good at it" and occasionally buys spot news or feature photos from others. "We'd buy more photos from freelancers if they'd bring us what we're looking for."

What he and other chief photographers or picture editors are looking for are good, sharp photos that "say something." Even when they publish three or four photos of an event, at least one of the photos must capture the *essence* of the story to tell the reader *what is happening*; the additional pictures serve to fill in the details, but usually a single photo has to tell the story.

For a fall issue of one of the papers, Howard selected the following photos: a cover shot of a young girl practicing for an indoor ice show; two photos of a youth symphony rehearsing; an informal portrait of a jewelry artist and a close-up of her work; a high-angle view of stores affected by a proposed shopping mall; a Salvation Army worker, his kettle, and a young contributor; a local politician at a belated victory celebration; a theater group performing in a school; two more photos of children practicing for the ice show; six photos (all purchased from a

Photos of outdoor signs stating the temperature—whether extremely cold or extremely warm—help tell the story. Shot with a Canon SLR and 50mm lens.

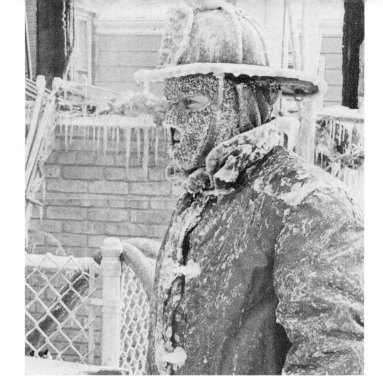

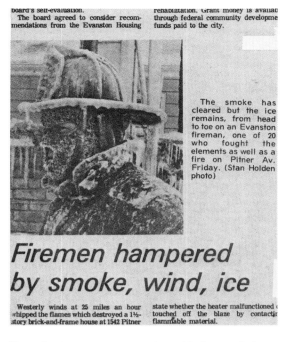

Firemen hampered by smoke, wind, ice

Since the temperature was about 10 degrees below zero at the scene of a local fire (note photo of fireman with ice on his helmet on right), the biggest problem was keeping warm. One of my photos was used in the local weekly (left). Taken with a Canon 35mm SLR, with a 50mm lens and Tri-X.

freelance) of a 4-H Club fair; men removing furnishings from an old hotel before it's demolished; action at a high school basketball game; a head-and-shoulders shot of a program chairman for a senior-citizens group; and a close-up of a bronze bust honoring the former chancellor of a local university.

Any of these photos could have been taken by a free-lance photographer. If they had been, the pay would have started at about $5 for the first photo and $3 for each additional photo of the same event. Sports photos pay more "because they're harder to take," Howard explains, starting at about $10 for the first one and $5 for each additional. (During the high school football season, a freelance could cover two or three games in one day—catching one or two quarters of each—and make as much as $45.) If a freelance's photo makes the front cover, he gets $15, and there are usually additional photos inside with payment.

All of the photographers on the staff use Nikons, with motors for sports, and an assortment of lenses ranging from 24mm to 500mm. On a typical assignment, a photographer will carry two camera bodies, a 24mm or 28mm wide-angle, an 85mm or 105mm short telephoto, and possibly a 300mm. The 500mm is used almost exclusively for sports. If at all possible, photos are taken with available light. If not possible, a speedlight is used with the light bounced off a ceiling for most shots. Tri-X, usually rated at ASA 400, is the preferred film, and it's developed in Acufine. When necessary, the film is rated at an E.I. of 800, 1200, or as high as E.I. 3200 and developed accordingly. Each staff

photographer does his own developing and enlarging in the newspaper's darkroom, and Howard prefers that freelances bring in 8″ x 10″ glossy prints, not undeveloped film or negatives.

Although the average issue of each newspaper will contain only one or two spot news photos—and sometimes none—a scanner (a shortwave receiver that picks up police calls, automatically switching from one frequency to another as broadcasts start and stop) is on constantly in the photographer's office to alert them to any major fires, police action, or other emergency. "I used to have a scanner in my car," Howard told me, "but it got ripped off. But someone is usually here to monitor the calls, and we don't miss very many."

Can a free-lance photographer really make money selling to the local newspaper?

"Well," Howard admits, "you can't get rich at it. But, as I said, we're always looking for good photos and good photographers. We *do* give out assignments from time to time, when our staff photographers are busy, and I suppose many other papers do the same thing. So the thing to do is make up a portfolio of your best work and bring it in to show what you can do.

"And there's one more thing that's almost as important as getting the picture. That's getting the caption material—names spelled correctly and from left to right, the correct addresses, and so on. Just study the photographs in your newspaper and see how the pros do it."

Among the scheduled events a freelance can cover for the local paper, when the staff photographers are busy elsewhere, are luncheon meetings with noted speakers. This photo was taken with a Canon SLR and available light, using Tri-X. The exposure was 1/30 second at f/5.6.

3
Copying Photos, Slides, and Other Material

There's so much to say about copying photos, slides, and other material that you could write a book about it, and somebody has—Norman Rothschild, author of *Making Slide Duplicates* and *Titles and Filmstrips* (published by Amphoto); and/or read *Camera Copying and Reproduction* by O. R. Croy, and Kodak's *Copying* or *The Here's How Book of Photography*. The latter's chapters include "Titling Techniques" and "Slide-Duplicating Techniques."

This chapter, therefore, will not discuss how to do the work but, instead, how to make money doing the work, or, better yet, how to make money while *others* are doing the work.

For example, let's say you get an assignment to make duplicates of a quantity of 35mm color slides (in conventional 2″ x 2″ cardboard mounts). You could do it yourself if you had the right equipment and knew how to do it, and your profit would be the difference between the price you charged and your expenses for film and processing, or you could let a professional photolab do it and mark up their price a bit.

As this is written, a big independent lab in Chicago charges 95¢ for the first 35mm duplicate and 80¢ for each additional dupe from the same original, with 48-hour service. They also offer 24-hour service at a 50 per cent surcharge, or 8-hour service at a 100 per cent surcharge.

Kodak will do it for much less: 40¢ a slide (maybe more by the time you read this), with about five working days in the lab.

Of course, if your customer wants only part of the original slide copied, wants the color changed, or desires some other special treatment (e.g., two slides combined into one), you'll have to do your own shooting, and you *will* need special equipment.

One of the most versatile pieces of copying equipment you can buy is the Honeywell Universal ReproNar. Basically, it's an upright copying stand with two light sources built into it: an incandescent source for viewing, composing, and metering, and an electronic flash unit (with

high/low light selection) for the actual exposure. You attach your 35mm (or even larger) single-lens reflex camera to the Repronar, add a good enlarging lens or macro lens, and you're all set for a wide range of copying jobs.

With this setup you can: copy slides onto color positive, color negative or black-and-white film; reproduce filmstrips; reduce 6x7 or smaller transparencies to 35mm slides; produce black-and-white positive slides from black-and-white or color negatives; enlarge movie and half frames to 35mm; enlarge (with or without cropping) 35mm frames to 6x7; mask for exposure control; frame with masks; add textures and screens; create abstract color images; vignette; tilt for composition; create sandwich effects; zoom while copying; or devise your own special techniques.

At Coronado Photo, they use a 4" × 5" view camera and two quartz lights for copying photographs. The dark object through which the camera lens is peeking is to eliminate reflections.

For copying slides, Coronado Photo uses a Honeywell copying attachment and a Pentax, with a quartz light illuminating the original from the rear.

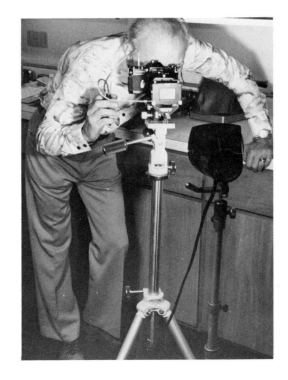

You don't always need expensive equipment for copying. To photograph some direct mail packages for a slide presentation, I reversed the elevator post of my tripod, extended the tripod legs to near maximum, and set up two photofloods. (They're on boom arms, but these are not always necessary.) The background was a sheet of colored poster board.

Other copying devices available include the Bowens Illumitran (which accepts any camera or original up to and including a 4″ x 5″), the Testrite Slide Copier, and several low-priced units offered by Spiratone (135-06 Northern Blvd., Flushing, NY 11354). The free-standing Copypro accepts cameras up to 8″ x 10″ and can be used to photograph opaque or transparent originals; it's available from Sickles, Inc., Box 3396, Scottsdale, AZ 85257. Then there's the Polaroid MP-4 System, designed for "instant" copies on 4″ x 5″ Polaroid film.

For making color or black-and-white negatives from individual frames of movie film, you can get a Testrite Cine-Larger, available in four models for regular 8mm, super 8, 16mm, and 35mm. These are shown in the catalog of Solar Cine Products, 4247 South Kedzie Ave., Chicago, Illinois 60632. For details and prices on a number of reasonably priced copying stands, refer to the big catalog from Porter's Camera Store, Box 628, Cedar Falls, Iowa 50613.

That's enough about copying equipment. The important question is, What kind of customers can you get for this kind of work?

The answer is: Almost everybody is a potential customer!

The most common are people who want copies of old photographs—wedding portraits of their folks or grandparents, pictures of their children when they were much younger, photographs of their business in the early days, pictures of their graduation class, snapshots of a pet that recently died, or any other photo, new or old, when the original negative is not available.

Other potential customers include advertising agencies and public relations firms that need copies of artwork, charts, etc., for reproduction purposes or for slide presentations; publishers of books and magazines who need copies of paintings, photos, or other material for reproduction purposes; museums and private collectors needing copies of original art for their files, for insurance purposes, or, for reproduction; film societies requiring blowups of movie frames for publicity or advertising; libraries; insurance companies; attorneys; authors; scientists; schools; amateur and professional photographers; artists; historians; camera shops; and government agencies. (Incidentally, the copying of paintings and other large objects with highly reflective surfaces requires polarized lights and special techniques; see Croy's *Camera Copying and Reproduction*.)

Besides copying, you can also make money preparing and shooting titles—as slides or on movie film (many copying stands will also accept movie cameras)—for ad agencies, public relations firms, industrial companies, lecturers, amateur and professional moviemakers, and others.

Before you go out after customers, decide exactly which copying or titling services you plan to offer, practice with your equipment until you're certain of the results, and work up a price list based on your expenses and desired profit. Then you can either call on prospective customers in person or conduct a modest direct-mail campaign; in either case, use a simple advertising flier to list your services and prices. Later on, you can add more services if there's a demand for them.

4
Pet Portraits

Take a look in the *Yellow Pages* under "Photographers," and chances are you will *not* find a photographer specializing in—or even offering to take—photos of pets. Yet there are more than 26,000,000 dogs, 21,000,000 cats, and God only knows how many parakeets, hamsters, gerbils, canaries, white rabbits, monkeys, and other household pets in this country. Many of their owners would be willing, even delighted, to pay good money for a halfway decent black-and-white or color portrait of their pet(s), if only they knew of a photographer who would do the work.

Make no mistake—work it is. Even if you're a pet lover, taking good pictures of animals isn't all fun and games. You must have fast reflexes, infinite patience, an understanding of animal psychology, in addition to the ability to operate your camera equipment quickly and correctly.

However, the rewards are worth it. You'll probably have no difficulty getting $25 or more for an 11″ x 14″ black-and-white pet portrait, or $40 or more for a large color print.—and that's just for sales to pet owners.

In addition, there are at least half a dozen other types of potential buyers, and some of them are willing to pay as much as $2,000 for one photograph!

Of course, for $2,000 your photo has to be darn good, but that's the kind of money a top animal photographer like Walter Chandoha often receives from advertising agencies and manufacturers of pet foods. Chandoha's photos are used in consumer and trade ads, for store displays, and on pet-food cartons and cans.

Another big market is magazines. Eye-stopping color photos of dogs, puppies, cats, and kittens (and occasionally other pets, too) are used on the covers of a wide range of publications—consumer magazines (e.g., *Woman's Day, Family Circle*), Sunday supplements

(*Parade, Family Weekly*), internal and external house organs, juvenile magazines, and trade journals. Pet photos are also used inside the magazines, either to illustrate an article or as picture stories.

Other markets include: books (especially children's books), encyclopedias, greeting cards, posters, calendars, stationery, and jigsaw puzzles. See *Artist's and Photographer's Market* or *Writer's Market* for possible buyers.

The best way to start, and gain experience at the same time, is to photograph pets for their owners. You'll need a single- or twin-lens reflex camera with a normal or short telephoto lens, a tripod, some speedlights, and a tabletop "studio"—a large, solid-colored blanket or a roll of seamless background paper on a card table or other platform, with the blanket or paper forming both the horizontal and vertical surface. If the pet is small enough, a basket or other container can be used to keep him in one place. It also helps a great deal to have an assistant (unseen by the camera), to hold the pet, help keep him on the platform, or attract his attention (with a bit of food, a squeak toy, or some other noisemaker).

You could get by with floodlights and high-speed film shooting at 1/250 sec. or 1/500 sec. to stop movement, but speedlights flashing at 1/1,000 sec. or less will stop all movement and are far easier on the pet's eyes. However, for best results, you'll need at least two speedlights, or better yet, three or four. Ideally, they should have modeling lights and a fast recycling time, so you can aim them better and shoot a number of pictures in rapid succession. The extension units should have photocells for slave operation to avoid a tangle of cords.

Before setting up in business as a pet photographer, get plenty of practice by photographing at no charge the pets of friends, neighbors, and relatives. You might limit your subject matter to just dogs at first and then cats, before attempting to photograph others animals or birds. Give each owner an 8″ x 10″ print or two in exchange for signing a

Our Welsh terrier, Charley, is happy to pose for a formal portrait. Taken with a Rolleiflex and three speedlights: one at a 45° angle in front, and a backlight at each side (left). On the right, a rare shot of a bird sitting still.

model release, in case your photographs turn out good enough to submit to a magazine or some other market.

The release should say something like this:

> For consideration received, I hereby consent that (your name), or any persons or firms with the consent of (your name), may use photographs taken by him of my animal for all editorial, illustration, and advertising purposes.
>
> Signed_____ Date _____
> Address_____
> City, State_____ Witness _____

The person signing the release must be of legal age. Attach the release to a contact print or duplicate slide of the pet, so later on you'll know to which photo(s) it pertains.

Once you have enough practice and a portfolio of two dozen or more pet portraits, you can get customers by advertising in the local newspaper (include a sample photo in the ad) or by arranging to exhibit your samples at the public library, a local school, or some other public place. A neatly lettered sign, such as *Photographs by (your name) (your phone number)*, should soon have potential customers calling you for more information and prices. You might also be able to get some free publicity by showing your photos to the editor or photo editor of your local newspaper.

Neither a kitten nor a full-grown cat, this four-month-old feline was not the most cooperative model. Photo on left was taken with a Rolleiflex and three speedlights. Since the cat wouldn't sit still any longer, it was necessary to have her owner hold her from below, while the cat looked over the back of a chair covered with a blanket. A Canon with a 50mm lens and three speedlights were used (right).

Another way to attract customers is to tie in with pet shops, dog breeders, boarding kennels, dog groomers, and even veterinarians. Ask if they'll let you put up a display of pet photos—perhaps you might change them every month or two—to help decorate their place of business. Many will be happy to do so with no strings attached. A few will ask for a commission on any business the display generates.

Although I wouldn't recommend you go into pet photography on a full-time basis, it could be a lucrative way to spend your spare time. First, even before you practice photographing pets, read as much as you can about it and study the photographs of others. Walter Chandoha's *How to Photograph Cats, Dogs, and Other Animals* is must reading (if you can find it at your camera shop, bookstore, or library). Also see Mildred Stagg's *Animal & Pet Photography Simplified,* available from Amphoto. Picture books include *Walter Chandoha's Book of Puppies and Dogs* and *Walter Chandoha's Book of Kittens and Cats.*

One final suggestion on selling your pet pictures—try a stock photo agency. This is a firm, usually in New York or some other major city, that maintains a library of color transparencies and/or black-and-white photographs categorized by subject matter. When a magazine's picture editor or an ad agency's art director or some other photo buyer needs a specific photo, he'll often contact a stock photo agency and ask to see what they have on file. If he needs a certain type of pet photo, and your photo is among those submitted by the stock photo agency, you have a chance to make a sale. Although the agency keeps 40–50 per cent of the money received, they usually sell only one-time publication rights, and a photo may be used by dozens of buyers. Chandoha's picture of a goggle-eyed Weimaraner has been sold more than 25 times. For more details on working through a stock photo agency, see *Where & How to Sell Your Photographs* by Arvel W. Ahlers, published by Amphoto.

If you can't get the pet to hold still long enough for a portrait, have a youngster hold it. It's not a "pure" pet portrait, but the family will love it anyway. Taken with a Rolleiflex.

5

"Old-Time" Portraits

Return with us now to those thrilling days of yesteryear, when some 20,000,000 tintypes were turned out during the Civil War and post-war period, up until the last years of the nineteenth century when George Eastman's roll film proved successful.

The tintype has returned, and it's possible for you to make money with it if you know how to do it and if you're in the right location.

In order to make a profit taking portraits of present-day people while using "old-time" photographic equipment, it's essential that you set up shop (either a permanent studio or a portable one) where there is traffic, lots of it. To quote from *The Tintypist's Companion,* an excellent manual published by Elbinger & Sun, Inc. (more about them later): "Go where people spend money. Antique shows are the best. Craft fairs are also pretty good. Small town festivals—like centennials, apple blossom festivals and the like—are not so hot. Civil War re-enactments and skirmishes are great fun and usually very good business. The buffs know and appreciate tintypes, will pose excellently, and have their own outfits and props."

Permanent "old-time" photo studios have been established in or near various tourist attractions around the country, including Harpers Ferry. WV; Cripple Creek, CO (an historic gold-mining town); Knott's Berry Farm and Universal Studio, both near Hollywood, CA, and Marriott's Great America amusement park near Chicago.

At Great America, the G.M. Hostage Tintype Store averages about 200 customers a day during the park's season (the warmer months only), according to a write-up in the Chicago *Tribune:* "Like most subjects for replicas of tintypes, the clients dress the parts—of Black Bart, Doc Holliday, Yukon Lil, and other period characters. They also stand in front of an appropriately dated backdrop. The finished pictures are $4.50 for a 4-by-5-inch size, $9.95 for an 8-by-10. Mounting on a plaque of barn wood is an additional $9.95."

An article by Ed Hannigan in *Studio Photography* magazine told how two young men from the East—Jerry Hannigan (presumably the author's son) and Scott Warren—established the Great Rocky Mountain Tintype Co. in Cripple Creek, where "thousands upon thousands of tourists are attracted to the area because of its picturesque and historic setting. . . . The studio's 12-foot-high windowed front and open triple-folding doors are an invitation for the tourists to come in. With framed print exhibits of old-time photos and the portrait operation to look at, the studio has become a popular attraction all of its own. . . . Customers who wish to be tintyped have a choice of a number of custom-made authentic period costumes in which to be photographed. Besides the outfits of the 1890s, there also are Civil War Blue and Grey general's uniforms for selection. The costumes are made to fit over street attire and are 'universal-sized' in that the backs are split open and have Velcro fastening straps for quick on-off fittings. Appropriate hats, shotguns, pistols, canes and other props are at hand to complete the costuming."

The Great Rocky Mountain Tintype Co. is also mentioned in *The Tintypist's Companion,* since much of the equipment and methodology come from Elbinger & Sun, Inc. (2345 Hamilton Road, Okemos, MI 48864). "There are two posing areas . . . on the right is a grey-toned outdoor landscape (the Rocky Mountains, of course). On the left is a three-dimensional set: a replica mine shaft. With an old ore car and a load of readily obtainable local gold ore, the set is quite unusual."

Here's an "old-time" portrait from "Professor" Bloodgood's Photographic Emporium.

Besides publishing the manual (a great buy at $9.50 plus 50¢ postage), Elbinger & Sun, Inc., offers the replica Anthony camera. "Our five by seven inch format camera is an exact reproduction of the most popular tintype camera of the nineteenth century. It is made from mahogany and is completely handmade. Each one is a unique piece of work—the kind of work that's hard to find in the 1970's. The camera includes two plate-holding backs and one high quality view camera lens, with variable aperture. The camera also is fitted with a Packard shutter. It'll be the best prop in your studio. And it's so beautifully simple, your customers will ask you if you have a modern camera hidden inside.

"The cost of our complete camera is $750.00 (1976 price) plus shipping charges from Okemos, Michigan. Also included are inserts for the back to accept 4″ x 5″ and 3″ x 4″ plates."

Since it's a working camera, the firm can also supply you with tintype plates; unlike the original wet-plate kind, these are dry (no coating to be done just before the exposure) and safe to use (no messing around with potassium cyanide). At last report the prices were: $1.75 each for a 3″ x 4″, $2.50 per 4″ x 5″, and $3.50 per 5″ x 7″ (or $3 in quantities of 100 or more). Prices include developer on orders for 50 or more plates.

Besides a fixed and/or mobile studio, the camera, and the plates, you'll need about $50 worth of darkroom equipment (three 5″ x 7″ tanks, a safelight, a large tray for rinsing, and some print hangers); about $50 worth of lighting gear (four 12″ reflectors plus blue photofloods); up to $1,000 worth of costumes (Elbinger's manual includes a costume source list); $100–$1,000 worth of props and furniture (posing chair, backgrounds, etc.); and sufficient publicity and promotion to keep the customers coming in on a steady basis.

The Elbinger & Sun, Inc., system is the closest thing I know of to the authentic tintype process. However, if you are not a purist, you may be interested in a competitive system, one that uses the Polaroid process instead.

According to "Professor" David L. Bloodgood, of Prof. Bloodgood's Photographic Emporium (3837 Mariana Way, Santa Barbara, California 93105), "Our company has been involved in the instant photo studio concept for the past seven years. During this time, we have established three major studios of our own in California and have sold studio setups, trained or supplied over 200 others across the country. In addition, our 'do-it-yourself' book package has aided thousands of individuals.

"Prof. Bloodgood's Photographic Emporium has taken more than a quarter of a million photos in the last three years, making our operation the most successful of its kind in the nation today. During the summer months, our studio located at the Universal Studios Tour in

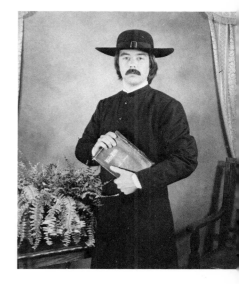

Here's another recent "old-time" portrait, taken recently, using equipment, props, and costume furnished by "Professor" Bloodgood.

Hollywood takes a photo every three minutes, eight hours each day, seven days each week. Our other shops and those operated by our studio setup customers have proven that even medium-traffic tourist locations and local shopping malls can be highly successful and proportionately lucrative.

"Some of our customers have found old-time photos a profitable addition to their existing restaurant, gift shop, casino, or portrait studio business. Others are outfitting vans and motor homes to tour fairs, rodeos, conventions, expositions, and the like."

"Professor" Bloodgood offers a do-it-yourself handbook package for $19.95 plus $2.50 for UPS delivery. It includes a complete handbook, sample photos, costume pattern, sample ad poster and flier, sample floor plans, and a list of suppliers. For $3,950 plus shipping, they'll send you their Deluxe Polaroid Set-up. This includes everything from an antique-style view camera with a Polaroid back (plus lens, tripod, Larson SoffBox lighting system and dark cloth) to a wardrobeful of nineteenth century costumes and an antique-style backdrop, along with enough Polaroid film to do $2,000 worth of business at an average charge of $5 per shot. You also get two full days of training at Bloodgood's studio in Santa Barbara. (Transportation extra.)

The "Professor" also offers the Basic Diffusion Transfer Set-up, which employs a large format camera (5" x 7", 8" x 10", or 11" x 14") and materials for turning out sepia-toned prints that are dry and ready to mount in two minutes, at a cost to you of only about 12¢ per 5" × 7". There are other package deals, too. Write him for more details.

In fact, write to both companies (Elbinger & Sun, Inc., and "Professor" Bloodgood) and compare their systems—or devise your own. Then make sure your intended location is good enough to support this unique type of business.

6
Real Estate Photography

You won't get rich doing real estate photography, but it's a relatively easy way to make a steady extra income. In most cases you can handle the assignments in your spare time, providing your spare time is during daylight hours.

Photographs of houses, apartment buildings, and commercial property (stores, office buildings, factories, restaurants, etc.) are needed by real estate firms to show prospective customers, so they can narrow the selection down while in the office instead of having to visit every site personally. The photos may be used by only one real estate firm—those with an exclusive listing—or they may be reproduced in quantity when multiple listings are offered to a number of real estate agencies.

In addition to the prints used in the real estate salesmen's loose-leaf binders, other prints are usually needed for newspaper ads and/or for display in the window of the real estate office. When commercial property is for sale, photos are sometimes used in trade magazine ads.

Almost any decent camera with a sharp lens may be used, from 35mm on up. Many real estate agents do their own photography with a Polaroid camera, but unless it's a model that accepts P/N (which provides a negative as well as a print), you're better off with a conventional camera in order to facilitate the making of extra prints. For the highest quality, use a 4″ x 5″ view camera, which has swings and tilts for correcting distortion, or a 35mm SLR with a perspective-control lens, which also corrects distortion though to a lesser degree. A tripod for steadiness, and for permitting you to use a smaller lens aperture even with slow film, is advised.

Most real estate assignments call for just one or two photos of the exterior of a building. However, when trying to sell a high-priced private home, an estate, or commercial property, many agents prefer a series of photos—half a dozen or more. Since these often include interior views, you'll also need a couple of photoflood or quartz lights on stands, and extension cords.

When shooting exteriors, try to frame the building with foliage (some photographers even bring their own when none is available on the site), or at least try to shoot when the sun is at the best angle for dramatic shadows. For buildings facing east, this means the early morning. For buildings facing west, it's the late afternoon, and for buildings facing south, almost any time except high noon is usually good. When photographing buildings facing north, you'll either have to shoot into the sun (not good) or wait for an overcast day. As part of a series on an office building, you might also take some dramatic night shots, using a short time exposure to let the office lights register.

When shooting interiors, try to use the natural room lighting—daylight and artificial lighting—whenever possible. If there are dark areas that you want to light, try bounce lighting (off the ceiling or wall) with your photofloods or quartz lights. Let your light supplement—not wash out—the natural lighting, unless the natural lighting is too spotty for a good result.

How much money can you get for photos of real estate? It depends on how much competition there is in your area, how the photos are used, and how fast you must shoot and deliver them. If there are other photographers in your area who wouldn't mind the business, if the photos are used for exclusive listings and local newspaper ads, and if overnight service is not required, figure on $10 or so per photo. This can be worthwhile if you have assignments for three or four photos per trip. Higher prices can be charged if you're shooting for a trade magazine ad and, of course, if you're doing a series on an estate or some commercial property.

Even at $10 per shot, if you can shoot four homes in about two hours and can get steady assignments from several real estate firms, it may be enough to help pay the rent or to buy additional camera equipment.

Other potential customers include building contractors, architects, insurance companies, and the home owners themselves.

In fact, you may wish to specialize in the photographing of homes for home owners. In this case, you should first shoot three or four homes on speculation, taking as much time and effort as you need to get outstanding results. The owners of these homes may or may not buy the pictures. In either case you'll have samples to show prospective customers. You might offer a package deal—three 11″ x 14″ black-and-white prints (different views) for $50. After expenses you should clear about $35–$40, or you can shoot with color negative film and offer 11″ x 14″ color prints at $35 each. (Your cost, from a professional lab, is about $7, plus the cost of film and processing.)

There are several ways to make money in real estate photography. Try one.

Photographs like this one are used by real estate firms to show prospective buyers.

7
Advertising Postcards and Brochures

How would you like to take one—or possibly two or three—color photographs at one location and make a good profit, and then make *repeat* profits again and again and again? It's quite common when you take photos—and orders—for advertising postcards.

You can concentrate on taking black-and-white or color photos for advertising brochures and make a profit on the photography alone, or on both the photography and the printing of the brochures.

There's a big market out there for advertising postcards and brochures—hotels, motels, restaurants, nightclubs, tourist attractions, resorts, real estate developers, swimming pool contractors, fencing contractors, home or office remodeling contractors, private schools, retail stores, manufacturers of consumer or professional products, and other companies offering products or services to homes or businesses.

An advertising postcard with one to three color photos, or a brochure with up to a half a dozen or so photos, plus some advertising copy (which you, your client, or a free-lance copywriter can supply), delivers its sales message at a reasonable cost. Once a postcard or brochure proves successful, you can usually count on your client ordering additional quantities, or having a new version prepared and printed, at frequent intervals.

So if you do a good job the first time (hold onto the reproduction rights for reprints), you can expect repeat business (and profits) for an indefinite time.

Perhaps the easiest way to get started in this business is with brochures featuring black-and-white photos for local business firms. There are several ways to work.

You can contact the firms yourself (the neighborhood furrier, air-conditioning and heating contractor, juvenile shop, or whatever) and arrange to do the entire job: photography, copywriting, typesetting, keyline (assembling the type proofs and screened photos on mounting

boards for offset printing), and the printing. Free-lance or moonlighting copywriters and commercial artists can do the writing and keyline work for you, a typesetting house (check your phone book) can use "cold-type" equipment (IBM Composer, etc.) to set the type at moderate cost, and there are plenty of local printers eager for all the printing jobs they can get. For brochures or booklets of eight pages or more, though, consider mail-order printers specializing in this kind of work, such as the Whitehall Co., 1200 South Willis Avenue, Wheeling, Illinois 60090, or Speedy Printers, 23780 Aurora, Bedford, Ohio 44146. Be sure to get quotations from all these people before contacting a potential brochure customer. If you can standardize your work as to the page size, number of pages, number of photos, and amount of copy, so much the better.

Another way to work is through a small advertising agency or commercial art studio. Let them handle everything but the photography. But, unless you find the customers, they may keep all the profit on re-orders (unless you have a written contract stating otherwise).

A third way is to work through printers. Find a printer whose work is good but reasonably priced, who respects deadlines, and who has a number of customers who might need brochures. If he can also handle the typesetting and have outsiders do the writing and art preparation, it leaves you free to concentrate on the photography.

Almost any camera can be used for illustrating brochures—from 35mm on up to 8" x 10". For product photography, a 4" x 5" view camera may be best, especially if distortion correction is necessary. *(See the chapter on small-product photography.)* However, if you're photographing live models—either professionals or amateurs—you can work faster with a single- or twin-lens reflex such as a Hasselblad, Rolleiflex, or Nikon. (Don't forget to have each model, and anyone else appearing in your photos, even if they're in the background, sign a model release.) For interiors of stores, homes, or offices, any camera with a wide-angle lens will suffice for most shots, but once in a while you'll need a special wide-angle camera such as the Brooks Veri-Wide 100 or the Horseman Wide-Field. Unless a special camera is needed frequently, try to borrow or rent one rather than buy one.

In most cases, lighting equipment need not be elaborate. For some brochures you can shoot with just the available light, but usually you'll need at least two or three lights (photofloods, spots, quartz lights and/or speedlights) along with portable stands, extension cords, a meter, and other standard accessories.

Naturally, the film processing has to be perfect. If you don't do your own developing and printing, find a local lab catering to professionals. Do not use a mass photofinisher catering to amateurs. If a custom lab isn't available in your area, you can deal by mail with one, for example, Gamma Photo Labs, 314 West Superior Street, Chicago, IL

60610. *(Also see the chapter on custom film developing.)*

Black-and-white photography for brochures can be very profitable if you do it on a steady basis. However, it's possible to make even *more* money, with *less* work, doing the photography and taking orders for advertising brochures and postcards *in color.*

Although the photography requires more care (besides sharpness and exposure you have to be concerned with the correct color temperature), there are a number of color printing outfits that will practically set you up in business (except for the photographic equipment needed) and handle most of the details for you. These include Dexter Press, Route 303, West Nyack, New York 10994; McGrew Color Graphics, 1615 Grand, Kansas City, Missouri 64108; Koppel Color, 153 Central Avenue, Hawthorne, New Jersey 07507; and Dynacolor Graphics, 1182 North West 159th Drive, Miami, Florida 33169. You can write to any of them and request a dealer starter kit with details and prices; enclose one dollar to help cover postage and handling.

Because their own costs keep changing and because additional items are often added, their price lists are revised about once a year, or even more frequently. However, a 1976 price list from Koppel Color will give you an idea of the kind of profits you can make in this field. The deposit, paid to you by your customer, becomes your profit on the printing order, and the customer pays the balance, on a C.O.D. basis, to Koppel when the order is delivered. Photography charges are additional and are set by you.

For Standard Color Postcards (3½″ x 5¼″)

Quantity	Selling Price	Deposit	Balance C.O.D.
3000 New Order	$170	$ 52	$118
Reprint	150	52	98
6000 New Order	212	80	132
Reprint	192	80	112
12,500 New Order	332	110	222
Reprint	312	110	202

(Additional prices are listed for quantities to 100,000.)

For Continental Cards (4⅛″ x 5⅞″)

Quantity	Selling Price	Deposit	Balance C.O.D.
3000 New Order	$204	$ 69	$135
Reprint	184	69	115
6000 New Order	276	97	179
Reprint	256	97	159
12,500 New Order	451	125	326
Reprint	431	125	306

(Additional prices are listed for quantities to 100,000.)

Koppel's price list also shows a variety of other items, including cards up to 9″ x 12″, calendars, and brochures on postcard stock. You'll notice that even though the customer pays less on reprints, your profit—the deposit—stays the same. The prices and selling practices of the other color printing companies are similar.

Like most of the other firms, Koppel's prices are based on using standard 2¼″ x 2¼″, 2¼″ x 2¾″, 2¼″ x 3¼″, or 4″ x 5″ color transparencies. If a 35mm transparency is used, there is, at this writing, an additional charge of $5. There are also extra charges for using a 5″ x 7″ or 8″ x 10″ transparency. (On January 1, 1977, Dexter Press announced that they have discontinued the extra charge when 35mm transparencies are used, and the other firms may have followed suit by this time.)

What kind of camera equipment should you use? Although 4″ x 5″ view cameras are sometimes used, especially when distortion correction is required (e.g., when photographing tall buildings), most of the pros in the postcard business seem to be using 2¼″ equipment, such as a Hasselblad, Bronica, Mamiya RB67, or Pentax 6 x 7. All of these cameras accept wide-angle lenses, required when photographing most room interiors or even outdoors if you can't move back far enough to include what you want. Some pros also carry a special wide-angle camera, such as the Brooks Veri-Wide or the Hasselblad Superwide C, and many of them carry a Polaroid back, too, so they can check composition, focus, and exposure on the spot.

The price list issued by Dexter Press shows a wide range of products—all sizes of postcards, calendars, catalog sheets, brochures, envelopes, menu covers, letterheads, even golf scorecards. For example, they offer a 9″ x 8″ four-picture color brochure that folds once to fit into a No. 10 (business size) envelope. In 1977, a quantity of 3,000 had a selling price of $710 (23.7¢ each), with a deposit of $145; 6,500 went for $985 (15.8¢ each), with a deposit of $185.

So if you sold a customer 6,500 9″ x 8″ brochures, you could make a profit—on the printing alone—of $185, plus additional profits on reprints. You'd also make a profit on shooting the four color photos, and here you'd set your own prices, depending on your expenses, how long it would take, how far you'd have to travel, and how much of a profit you care to make.

Incidentally, many of the prices for postcards, brochures, etc., include a small amount of typesetting, perhaps 50 words. For additional typesetting, or for other special services, such as including line illustrations or perforating, the customer pays a bit extra. His 10 per cent deposit on these extra charges goes to you as *additional* profit.

There are larger brochures, too, with possibilities for even larger profits. Dexter offers a 17″ x 23″ 24-picture brochure with prices starting at $5,775 for 12,500; the deposit is $800 (1977 prices).

This two-color advertising brochure, for a real estate development, is typical of the kind of assignment calling for good photographs.

What kind of pictures are used in these brochures? Well, a 9" x 24" color brochure (which folds to fit into a No. 10 envelope) in Dexter's sample kit advertises a "planned vacation community for year 'round family enjoyment." The 17 color photos in it include shots of a lake with sailboats, an indoor swimming pool (two views), a cocktail lounge, a sauna, a billiard room, snowmobile riders, skiers, lodge buildings, a boy fishing, and a family at a picnic table. Most, if not all, of these photos could have been taken by any competent photographer with standard equipment.

In addition to the equipment already mentioned (cameras, lenses, and floodlights), you'll need a good exposure meter (unless it's built into your camera, and even then a hand-held meter is often useful), a color temperature meter (especially for interiors shot with available light), perhaps four or more fairly high-powered speedlights with slave triggers, a sturdy and tall tripod, color compensating filters, a polarizing filter, and a supply of model releases.

Many hotels, motels, resorts, and planned communities use color postcards and/or brochures by the thousands, re-ordering regularly, and if you're the photographer and control the reproduction rights, you opportunity for profits is unlimited.

Writing in the *MCG Bulletin,* published monthly by McGrew Color Graphics, one photographer tells how he started out:

"I knew nothing about photography, and even less about selling. But I invested about $500 in a 2¼" x 3¼" camera with wide-angle lens, tripod, etc. . . . which made me a photographer! I had business cards

Almost any business is a potential user of advertising postcards. This three-photo card, by Michael West Photography, was for a beauty salon.

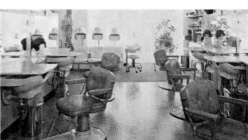

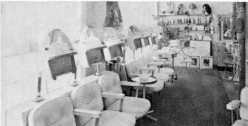

printed up . . . and that made me a professional! Since I knew so little about selling, I set a goal that I would make a minimum of 10 sales calls a day or 50 per week. This taught me the little things that one must know to be successful at selling color printing, like: what time of day to call on motels, restaurants, product manufacturers, etc.; what is the best approach; who is in a position to buy at each establishment; what to do if they show no interest; how many and what kind of samples to show; when to shut up and listen, and when to talk a blue streak.

"My first year, I damn near starved to death because of my ignorance in photography, selling, and color printing. But the important thing was that I never gave up . . . I taught myself photography the same way I taught myself the selling—by trial and error—and also by reading all books, scanning everybody else's brochures, cards, etc. . . . The next year got better. I got a few return calls and letters from people I'd left my card and samples with who said, at the time, they weren't interested. And a few re-orders came in, which sparked me on to bigger and better things. And I have never stopped working at it. . . . This is how I made over $50,000 in '73, and I'm looking forward to a better year in '74!" (Presumably, he's making even higher profits today.)

Whether you're interested in a full-time career or spare-time income, it will definitely pay you to write to one or more of the color printers listed earlier and/or check out the possibilities in shooting photos for black-and-white brochures.

8
Photos for House Organs

According to my copy of *the Random House Dictionary,* a house organ is "a periodical issued by a business or other establishment primarily for its employees, presenting news of the activities of the firm, its executives, and employees." In *Writer's Market,* the heading for its listing of "Company Publications" states, "Material for these company publications must perform a useful business service for the company." Other company publications whose subject matter is not directly product-related or primarily employee-directed are listed in various categories in 'Consumer Publications,' as well as in 'Trade, Technical and Professional Journals.' 'Association, Club and Fraternal,' 'College, University and Alumni,' 'Union,' and 'In-Flight Publications' are categorized under those chapter headings."

No matter what it's called, the house organ offers a pretty wide-open opportunity for free-lance photographers. In his *Where & How to Sell Your Photographs,* Arvel W. Ahlers points out, "It is estimated that approximately 10,000 to 15,000 house organs in North America print about 225,000 different photographs each week. Some of the house organs sponsored by major companies average between 50 and 100 photos each issue."

There's even an annual publication that lists nothing *but* house organs—the *Gebbie House Magazine Directory* ($40 from National Research Bureau, 424 North Third Street, Burlington, IA 52601, or free in the reference room of a well-stocked public library). This directory lists more than 3,000 house organs, with the name and address of each publication, the name of the editor, the type of business the sponsoring company or organization is engaged in, the kind of material (photos, articles, cartoons) bought from freelances, and the prices paid for this material.

Besides listing the companies alphabetically, Gebbie also lists them geographically, so you can make personal calls on the editors in

your area if you have photos you think they might purchase, or just to acquaint them with your work. In addition, there's a section titled "Editorial Material Requested by Editors" (with such headings as "Ecology," "Hobbies," "How-to Stories," and "Scenic Photos") if you specialize in certain subjects and want to sell photos from your files.

Basically, house organs are divided into three types: those aimed at employees only, those aimed at customers or potential customers (or donors if the sponsor is a charity) only, and those aimed at both groups. Perhaps the easiest type to break into as a free-lance photographer are the publications aimed at employees only—especially those publications operating on a tight budget.

In many cases, the editor is expected to double as a photographer and take pictures at company outings, dances, or whatever. However, if he or she is not a good photographer, doesn't have the time, or lacks the special camera equipment required for a difficult assignment, there's a chance for a local freelance to pick up a few dollars, perhaps on a steady basis. How much money? It varies tremendously, but the minimum for one shot should be $15, or $50 for a half day of shooting; try for more.

Shooting for an employee-directed house organ means, of course, that you should concentrate on photos of employees. Before taking any shots, explain to them why you're there—to avoid suspicion that you're a management spy— and try not to interfere with their work. Unless you're shooting to a layout, shoot both verticals and horizontals to give the editor or layout artist a choice, and get caption material, with every name spelled correctly.

The executive can be looking at the camera or busy at work. This executive was so busy he was actually photographed while reading a business contract.

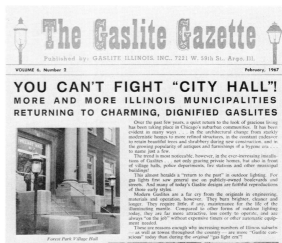

The Gaslite Gazette

Published by: GASLITE ILLINOIS, INC., 7221 W. 59th St., Argo, Ill.

VOLUME 6, Number 2 February, 1967

YOU CAN'T FIGHT "CITY HALL"!
MORE AND MORE ILLINOIS MUNICIPALITIES RETURNING TO CHARMING, DIGNIFIED GASLITES

This photo was one of many taken for an external house organ published by a manufacturer of gas lights to show how they were being used by municipalities, building contractors, retailers, etc. Taken with a Rolleiflex (left). *The Gaslite Gazette* regularly used photos of gas lamps installed at housing developments, city halls, etc. It was produced by an advertising agency (right).

External house organs—those directed to people outside the company or sponsoring organization—usually have larger editorial budgets and can afford to pay more for photographs. These are the ones you should look for in the market listings. They buy photos for cover use, as picture stories, and to illustrate articles, and if you can write as well as photograph, you have a better chance of selling your work to many of these publications.

For example, *Business on Wheels* is an external published by Goodyear Tire and Rubber Co. for distribution to owners and operators of truck fleets. They select a firm on which to do a case history, then assign a writer and a photographer (or, preferably, a writer-photographer) in the area to do the story, for which they pay from $250–$300 plus expenses. That's for black-and-white. They pay more for color, if they use it. (Color photos may be converted to black-and-white.)

Another example is *Discovery*, the Allstate Motor Club magazine. Although listed in *Writer's Market* under "Travel, Camping and Trailer," it's an external published by the motor club for its members and carries articles and photos about travel, with a few pieces on safety

and automotive subjects. The Winter 1976-77 issue included photos of whales, seals, and sea urchins; ski slopes and skiers; Williamsburg, Virginia; a church, fiesta dancers, and fireworks in Mexico; a sailing ship at a Newport, Rhode Island, wharf; campers in the snow; a multiple-image shot of a dog (for a short piece on camera tricks); and a group of ice fishermen. Most of these photos, which were in color, were purchased from freelances for one-time use, with the transparencies returned after publication.

You can also call the magazines found in the seat pockets of commercial airliners external house organs, although they're listed in *Writer's Market* under "In-Flight Publications." There are about 18 of them, with the editorial work for 7 handled by one company. All of the magazines use travel photos, and some of them also buy photos for articles on history, food, sports, the arts, business, ecology, personalities, outdoor recreation, crafts, science, aviation, life-styles, or how-to. Again, your best chance is to submit your photos with an article; the editor can always rewrite the article if he likes the photos. Most of the in-flight publications will send a sample copy to a would-be contributor for one dollar (to cover postage and handling). It's worth the investment.

Since the house-organ field is relatively unknown to most photographers, there's not as much competition as in the consumer-magazine field. But your work has to be good, and you must be able to carry out assignments, if given them, within deadlines.

Check out the market listings, then try your hand at shooting for house organs. Some pros do nothing else and make a good living at it.

This shot could illustrate an article in a house organ on salaries, borrowing money, or some similar topic. Taken with a Rolleiflex and two floods, with the currency purposely out of focus.

9
Magazine Covers

There's nothing quite like the thrill of having one of *your* photos on the cover of a national magazine, to be seen by millions of people all over the U.S. or throughout the world, and if it's a famous consumer magazine, an equally big thrill comes when you receive the check for your photo.

Unfortunately, your chances of selling a cover photo to a big-circulation, high-paying magazine are pretty small. Still, many have done it, and there's always the possibility that *you* can do it, too.

However, you have a better chance—a *much* better chance—of selling cover photos to not-so-famous magazines, for fees ranging from as little as $5 or $10 to as much as $150 or even more. Also, it's possible to do this on a regular basis if you specialize in it.

It's possible you may already have some photos in your files that would be suitable for covers. (They need not all be color photos; some magazine covers are in black-and-white.) Your best bet is to first study the market and then shoot some photos—on speculation—for submission to various magazines.

The most complete and up-to-date listing of magazines buying cover photos (and/or articles, fiction, cartoons, etc.) is found in *Writer's Market,* which is published annually and available through bookstores or at public libraries. Among the hundreds of magazines buying cover photos, according to the 1977 edition, are: *Saga* (paying about $150), *Women in Business* ($75), *Motor News* ($150), *Sail* ($300), *Marriage and Family Living* ($125), *Cats Magazine* ($100), *Model Railroader* ($112), *Fire Engineering* ($75), and *Selling Sporting Goods* ($75–$100). Some magazines, such as *The Lookout,* pay about $20 for a cover photo in black-and-white, while *Rockhound* pays $5–$35 for color covers. See *Writer's Market* for detailed editorial requirements.

Another annual publication, *Artist's and Photographer's Market,* contains (according to the cover blurb of the 1977 edition) "3,667 list-

ings covering 9,168 paying markets for free-lance artists and photographers.'' Besides magazines buying cover photos (and photos for inside use), the listings describe the needs of other photo buyers, such as advertising agencies, public relations firms, audiovisual producers, stock photo agencies, greeting card publishers, and record album producers. (Incidentally, if your local bookstore doesn't carry *Writer's Market* or *Artist's and Photographer's Market*, they're available by mail from Holden's, Box 1, Evanston, Illinois 60204. The 1977 edition of *Writer's Market* was $13.50 plus 50¢ postage; the '77 edition of *Artists and Photographer's Market* was $10.95 plus 50¢ postage.)

A third market listing, aimed only at photographers, is found in *Where & How to Sell Your Photographs,* a guide to free-lance photography written by Arvel W. Ahlers, published by Amphoto, and updated every few years.

All of these publications list not only consumer magazines (the kind found on magazine stands and in drugstores), but trade journals, too, which are usually available only by subscription and are directed to a specific audience, such as contractors, shoe retailers, or dairy farmers. They also list house organs published by companies to tell their employees and/or customers about activities the companies are engaged in, new products or services, etc.

The most up-to-date information on markets for the free-lance photographer is the brief news items in *Writer's Digest* and *The Writer,* two monthly magazines (primarily, but not exclusively, for writers) available at large magazine stands, at libraries, or by subscription. Besides listing the current editorial needs of various magazines, they carry announcements of brand-new publications which, obviously, need just about everything, including (in many cases) cover photos. Be wary, though, because many of the new magazines fold after a few issues, and some contributors don't get paid for material that was used, while other have a difficult time getting their unused material returned to its owner.

After studying the market listings and selecting a number of magazines which might purchase cover photos from you, stop at a magazine stand or the library and see if they carry the magazines you selected. (You can also write to the publications for a sample copy, telling why you want one; the market listings usually indicate whether or not a charge is made for sample copies.)

Then study each cover photo and make a note of the following: subject, pose, props, background, dominant colors, and placement of the subject in the total picture area. Most cover photos are verticals, with enough room at the top for printing the name of the magazine (logotype) and, often, room on one or both sides for printing cover blurbs about the contents of that issue. However, many cover photos are square, and some are horizontal. If the magazine has a gatefold

Animals are another popular cover subject, especially if they exhibit a little personality such as this one (note the baleful look). Lisa Holden snapped this one at the zoo, with a Canon 35mm SLR.

There are dozens of magazines buying cover photos, but you've got a lot of competition, too. Try for the lesser-known publications first, while you gain experience.

cover—opening out to twice its normal width—a horizontal photo is almost always used. (At other times, two or more photos are used.)

For general-interest consumer magazines and many other publications, the most popular cover subjects seem to be pretty girls, babies and pre-school children, pets, flowers, scenics, wildlife, food, personalities and sports action. Certain subjects (food, personalities, and sports) are usually shot on assignment only, by pros who specialize in those subjects.

Naturally, magazines specializing in specific fields almost always have cover photos relating to those fields. Thus, an electronics magazine will show electronic gear, a sailing magazine will show one or more sailboats, etc. Many of these photos are shot on assignment, but editors will often buy a photo submitted on "spec" if it's good, if it happens to fit in with a story they're running that issue, and/or if they have no other cover photos on hand. Even if they reject all your cover photos, they may very well keep your name and address in their files and give you an assignment for a cover photo. This is especially true if they need a specific photo shot on location in your area. Few editors can afford to send a photographer any distance to shoot one or two pictures.

Another way to sell cover photos is to shoot picture stories or illustrate magazine articles. If the editor features a particular story on the cover, with a cover blurb, he'll often select one of the photos and run it on the cover. If the story was originally illustrated in black-and-

white, he may ask the photographer (or a different photographer) to shoot one pose over again in color.

For many years, the majority of editors accepted only 4″ x 5″ color transparencies for cover use because, among other reasons, their photo engravers preferred working with the larger sizes. Today, however, many (though not all) editors will accept any size color transparency as long as it's sharp, the colors are good, and the subject matter is appropriate. Some actually prefer 35mm color slides—especially Kodachrome

This is a black-and-white reproduction of a cover layout, as prepared by the art director of this national magazine. The cover photo is a section of a 4″ × 5″ Ektachrome shot by staffer Bob Livingston. Notice how an abundance of sky area was used for overprinting the magazine's logo and the various copy blurbs.

slides. (Kodachrome, available for still cameras only in the 35mm and 110 sizes, has finer grain and better sharpness than Ektachrome or other color transparency films.)

The fastest Kodachrome currently available has a film speed of ASA 64. So if you need something faster or use a 2¼″ or larger camera, you'll be shooting on Ektachrome, GAF Color Slide Film, Fujichrome, or something else. Whatever you use, keep in mind that color transparency film has far less exposure latitude than black-and-white, so bracket your exposures to make sure that at least one shot is right on the button. If your exposure meter or the guide number for your speedlight indicates an $f/8$ aperture, shoot at $f/8$, but also shoot another at $f/5.6$ (one stop over) and a third at $f/11$ (one stop under). If you're more confident, bracket to the nearest ½ f/stop. On sunny days, when there's a tremendous difference between the highlights and the shadows, you may want to lighten the shadows with fill-in flash or a reflector.

Incidentally, color negative film such as Kodacolor has more exposure latitude than transparency (positive) film, but few editors will accept color prints for cover use. However, they might accept color slides made from color negative film if the colors are perfect, and Kodak will do the lab work for only about 50¢ a slide. (If you want to be sneaky, remount the slide so the mount doesn't say Kodacolor.)

When you have color transparencies to submit for possible cover use, never mount them in glass. The glass is likely to break in the mail and cut into your transparencies—and the editor's hands. Instead, use one of those 9″ x 11″ sheets of translucent, flexible plastic fitted with 20 pockets (for 35mm slides in 2″ x 2″ mounts) or 12 pockets (for unmounted 2¼″ x 2¼″ transparencies). They're available, for 20¢–40¢ each, at many camera shops. Larger transparencies can be mounted between two sheets of black cardboard, with an opening cut slightly smaller than the transparency (in a clear acetate sleeve) and possibly backed with a sheet of matte acetate to diffuse the light for better viewing. Ready-made mounts like these are available at camera shops catering to professionals or direct from the manufacturer (e.g., Studio Specialties, 409 West Huron, Chicago, Illinois 60610; theirs are without the acetate).

Each photo should be identified with your name and address. You can have a small rubber stamp made, but more versatile—and cheaper—are those name-and-address gummed stickers sold by mail for a dollar or two. Mine say: *Photo by Stan Holden* (followed by my complete address). You can affix a gummed sticker to each slide mount and even to the back of 8″ x 10″ black-and-white prints sent to magazines using black-and-white covers.

Put a code number of each slide mount (A1, A2, etc.) and then, on a sheet of 8½″ x 11″ paper, type the code number and follow it with

caption material. Some magazines do not require caption material for their covers, while others want to know such things as the model's name, where the photo was taken (if a scenic), photographic details (if sent to a photography magazine), or information on the subject (if sent to a trade journal or other specialized magazine). At the top of the sheet of paper, type your name and address and state: Transparencies submitted for cover use, at your regular rates (or words to that effect). You might also add the publication rights you're offering: one-time, first, all, or whatever. (See *Where & How to Sell Your Photographs* for more details.)

If a live model is in the photos, mention that a model release is available—and be sure it is.

Pack your photos between two sheets of stiff cardboard. Include a self-addressed, stamped envelope (abbreviated to S.A.S.E. in the market listings) and, if you wish, a brief covering letter typed on printed stationery. Since most color photos are one-of-a-kind, it's best to insure them if you send them through the mails, but whether an editor will go through the trouble of insuring them for the *return* trip is the question. Keep a record of which photos were sent to which magazine and when. If you don't hear anything in six weeks, drop the editor a brief query.

By producing a steady stream of possible cover photos for a variety of magazines, by studying the market and seeing what type of photos the editors are using, and by turning out work that compares favorably, you're bound to start selling cover photos sooner or later.

Then you'll see for yourself what a thrill it really is.

10

Small-Product Photography

One of the best ways to make money in photography, either part time or full time, is to specialize in photographing small products. By "small" I mean anything that will fit on top of a table or in a small area on the floor.

Product photos—many of them with just a simple, seamless paper background—are used in abundance by advertising agencies, manufacturers, wholesalers, retailers, mail-order firms, manufacturer's representatives, public relations agencies, and magazines. The photos are used in newspaper and magazine ads, catalogs, brochures, salesmen's sample books, and annual reports. They're used to illustrate press releases and magazine articles, and if they're in color, they're even used for low-budget television commercials.

Almost any good camera may be used for product photography, but certain types have advantages in certain situations. For example, a photographer on the West Coast had to shoot hundreds of black-and-white product photos for an importer's catalog. Some of the photos were of tiny products; others were of larger items; and a number involved the use of amateur models. The photographer decided to use a 35mm single-lens reflex because he had to shoot fast (about three dozen products per day), he had to keep the cost down, and because distortion correction was not necessary.

Another photographer was called upon to photograph books for a magazine ad. Since the ad was to be in color and since the books were to be shot from a slight elevation (to show the thickness), he decided to use a 4″ x 5″ view camera. The 4″ x 5″ transparency film could be shot to size (*i.e.,* the picture in the ad is the same size as the image on the film), and he could use the camera's tilting front and back to correct for distortion (otherwise the books would appear to be wider at the top than at the bottom).

A third photographer had an assignment to shoot black-and-white

pictures of small items for a golf-accessories catalog. He decided to use an old 2¼″ x 2¼″ Rolleiflex because it gave him a bigger negative than if he used his 35mm single-lens reflex—and because it was the only other camera he had!

Perhaps the ideal camera for small-product photography is a combination of all three—a 4″ x 5″ view camera that accepts 4″ x 5″ film, roll film, or 35mm film. If you don't need distortion correction, consider a 2¼″ x 2¼″ single-lens reflex (e.g., Hasselblad, Bronica) or a 2¼″ x 2¾″ single-lens reflex (e.g., Mamiya RB67 Pro S Professional), which accepts 120 or 220 film or a Polaroid film pack.

One of the least expensive view cameras available is the Calumet, sold directly from the factory. It's available in several models, but for close-ups of small products I'd suggest the one with a 22″ triple-extension bellows, which sells for about $220.00. Add a 150mm or 210mm lens ($200.00 or $300.00), half a dozen cut-film holders ($5.25 each), a focusing cloth, lens shade, exposure meter, and tripod, and you've got a good camera outfit at a reasonable price. Other low-priced view cameras are made by Baco, Galvin (a 2¼″ x 3¼″ model), and Nagaoka. More versatile, and more expensive, models are offered by Sinar, Deardorff, Arca-Swiss, and Plaubel Profia.

Fortunately, you can often pick up a good view camera, complete with lenses and accessories, at a good price if you don't mind buying one used. Try a camera store specializing in professional items, or check the classified pages of your newspaper. Savings of 50 per cent or even more are not unusual.

For lights, you can get by with a couple of photoflood reflectors or quartz units on telescoping stands. Smith-Victor, among other firms, offers a reflector/socket/light-stand adapter for No. 2 photoflood bulbs or 500w, 3200 k bulbs for around $15, plus another $35 for an eight-foot aluminum stand. Barn doors are $20 and a diffusion screen is $10.

A number of companies offer quartz units, either focusing or non-focusing, at prices ranging from $30 on up. I'd recommend the focusing type, since some product photos require a sharply defined shadow or crisp sidelighting—difficult or impossible to get with a broad beam. A miniature spotlight, using a 150–250w bulb, also comes in handy.

At the minimum, you'll need three lighting units—for a main light, a fill-in, and as a backlight or toplight or to illuminate the background. Additional lighting units will permit you to light larger objects or the background more evenly.

Many product photos can be taken with direct light, but for a near-shadowless, high-key effect, or to photograph reflective objects such as silverware, you'll need diffused light. One way to achieve it is to construct a framework of 2 x 2's, cover it with a translucent material (available at professional camera shops, or use a white shower curtain),

and aim your lights through this diffuser. This eats up a lot of light, so you may wish to use one or two 1,000w floods or a cluster of 500w units. (Don't run more than 1,500w off the same electrical circuit.)

If you prefer, you can bounce your lights off a white ceiling, a white wall, a large sheet of white poster board, or even a photographic umbrella.

If you want to keep product photography as simple as possible, accept only the assignments that permit you to shoot with a seamless paper background. Seamless paper (developed for window trimmers) comes in rolls 107″ x 36′ (about $15 at list), 107″ x 150′ ($60), 52″ x 36′ ($8.50), and 52″ x 150′ ($31) in several dozen colors including super white and jet black. For black-and-white photography, you can get by with just a few rolls—white, black, light gray, and dark gray (or colors that photograph that way). For color photography, and especially if you're shooting numerous photos for the same catalog or brochure, you'll need at least eight or ten different colors.

The rolls of paper can be supported on a roll holder that attaches permanently to your studio walls or ceiling, or on a portable stand assembly (two vertical units plus a horizontal crossbar) that can be

To photograph small (tabletop) products, you need: a table, or sheet of plywood supported on two sawhorses; seamless paper; a camera with a close-focusing lens or close-up attachments; a tripod; three or more light stands; three or more floods and/or spots; an exposure meter, and accessories such as a staple gun, masking tape, a gray card (for measuring exposure), and small white cards for bounce lighting.

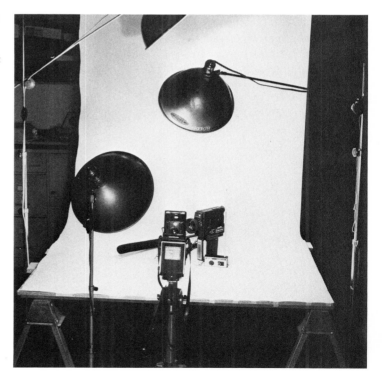

assembled or dismantled in minutes and used anywhere. The latter sells for $40 or more.

For tabletop photography, you can use the entire 107″ or 52″ width of paper, or use a saw to cut the roll to the exact width you need. Keep in mind that your camera lens will see more of the background width than the foreground width. That is, if your lens sees a three-foot-wide section of the front edge of the table, four or five feet of the background will be included. It depends on your lens, the camera-to-subject distance, and the distance from the front edge of your table to the point where the paper becomes vertical.

Your table can be just that—as long as it's sturdy—or a sheet of plywood, thick Masonite or other composition board supported on two sawhorses. I use metal sawhorses (from Ward's) with legs that fold in for storage. Support the seamless paper above and behind it, then unroll enough to reach down to the table and then forward to the front edge or a bit beyond it. You can tape or staple the paper to the table so it won't curl up. For objects too tall for a table, lay some wrapping paper on the floor and then unroll the background paper on top of the wrapping paper (which helps keep it clean).

If you're taking a number of photographs, arrange your shooting to minimize the amount of background-paper changing. For example, shoot all the photos requiring a red background first, then those with a white background, and so on. Also, try and keep camera movement to a minimum by photographing the smallest objects first, then the next-smallest, etc., if this is possible without changing backgrounds.

The photograph was made to accompany a magazine article written for *Consumers Digest*. Although the seamless paper background is actually a light yellow, it photographs as white if brightly lighted.

To photograph tabletop products, you need: seamless paper; camera with close-focusing lens, close-up attachments, or short telephoto lens; tripod; three or more light stands; three or more spots and/or floods; accessories for products; exposure meter, and a gray card.

Instead of seamless paper, some product photos can be shot using colored poster board. Either attach the poster board to a wall or other vertical support, or place it on the floor and support your camera above it. When photographing small objects, you can shoot from above by reversing the center pole of an elevator tripod or by securely clamping a tripod to the joists (if you have your studio in an unfinished basement). A copying stand may also be used. Some studios that do a lot of product photography shoot down from a balcony or have constructed a special overhead support for their cameras. (Leave room for looking through the groundglass of a view camera, or use a reflex camera with the groundglass at right angles to the lens, such as a Hasselblad.)

Of course, some product photos require more than just a seamless paper background, and this can be time-consuming and expensive. For instance, a photo of a desk calendar may require props such as a telephone, a telephone index, and a penholder, in addition to a desk (which might be only a sheet of wood paneling placed atop your regular table). Props can often be borrowed or rented from department or specialty stores, antique dealers, or other sources, if the photo studio doesn't have them in its prop collection. However, when you're just starting out, try to keep things simple, and either refuse assignments calling for props or have your client supply them.

Similarly, live models—although often pleasant and usually attractive—can be a problem, too, especially for the novice photographer. If a professional model is used, her time is valuable ($25–$50 an hour or more), and you must work fast. Also, if an amateur model is used, she or he must be carefully directed or the pose will be too stilted. Try to avoid using models if you possibly can, or at least until you gain experience.

The photography of reflective objects (silverware, jewelry, glassware) is another problem area and requires special knowledge, experience, and apparatus. Practice doing it in your spare time, but don't accept this type of assignment until you know what you're doing.

Despite these restrictions, there are still plenty of opportunities for the product photographer in almost any area of the United States—and the money is good. For example, in 1977 I did a small (very small) survey of prices charged for product photos in the greater Chicago area. The average price for a simple tabletop shot in black-and-white was between $40 and $50 and between $60 and $75 for color. These were prices charged by full-time professionals. Part-time pros charged perhaps half these amounts. In both cases, the price per shot was often less if more than one photo was taken with the same background, lighting, and camera setup. Location photography was higher and was usually figured according to the time involved: per hour or by the day or half day.

If you're just starting out, study what others have accomplished in, and written about, product photography. Study and clip product photos in brochures, magazine ads, and catalogs. Read books such as *The View Camera: Operations and Techniques* by Harvey Shaman; *Photography for the Professionals* by Robin Perry; *How to Make Money in Advertising Photography* by Bill Hammond; *Lighting for Photography* by Walter Nurnberg, and *Tabletop and Still Life Photography* by Edna Bennett. (These books are available at your camera dealer or from Amphoto.)

Then give yourself plenty of practice assignments until you're reasonably certain you can handle a real one. Print up one or two dozen samples—photos of different types of products—and start making the rounds. Call on art directors at advertising agencies, account executives at public relations agencies, ad managers at industrial companies and mail-order firms, and other potential clients. Show them what you can do, quote your prices, and ask for a sample assignment, preferably one that allows you enough time to re-shoot if necessary.

It could be the start of a lucrative part-time or full-time career!

If you don't have any seamless paper handy, shoot against a plain wall. It's not as good, but the photo, for a magazine ad, sold a number of director's chairs anyway. Taken with a Rolleiflex, using four floods.

11
Custom Film Developing and Printing

In several large cities (such as New York, Chicago, and Los Angeles), there are custom photolabs catering to professional photographers, discriminating amateurs, and others (e.g., advertising agencies, magazines) who want the best possible film developing, proofing and/or enlarging, and don't care to—or can't—do the work themselves.

Elsewhere, customers have to deal with these labs by mail (which not only takes more time but could result in lost films) or settle for the standardized, take-it-or-leave-it service offered by the mass-production photofinishers geared to the drugstore trade.

Therefore, if *you* live in an area that does not have a custom photolab, and if there are enough potential customers in your area, it may be profitable to open a custom photolab of your own. A Midwest freelance magazine photographer did just that in the late 1950's, built it up from the profits, and sold out to a conglomerate after a dozen years for a reputed $1,000,000!

On a more modest scale, two Evanston, Illinois, photographers started up a small custom photolab in 1952, and today, a quarter of a century later, it's still small—and that's the way they want to keep it. Besides developing black-and-white film, making oversize prints and proof sheets, and making black-and-white enlargements up to 16″ x 20″, they operate a small camera shop, but they stock only film, a few Kodak cameras and projectors, a line of low-priced speedlights, and perhaps $200 worth of other photographic merchandise. They make their profit from the custom work they do and from the color photofinishing they send out to Kodak and a wholesale photofinisher in Chicago.

Except for a part-time salesclerk, who sells film and writes up photofinishing orders, the two partners do all the work themselves. They make a 40 per cent profit on the color work they send out and about an 80 per cent profit on the black-and-white work they do them-

selves. However, out of this 80 per cent must come their salaries and overhead (rent, heat, electricity, water, etc.). The other 20 per cent goes for photographic paper and chemicals.

Because Kodak and other suppliers raise prices every year or so, or sometimes more often, they must periodically revise their price list, but the latest one looked like this:

Black & White Fine Grain Developing

Roll Film	$1.00
220 Film	2.00
135–20 exp	1.25
135–36 exp	1.50
Up to 4x5 sheet	.75
Film Packs	4.00

Contact (Proof) Sheets

135–20 exp	$1.50
135–36 exp	1.75
120–12 exp	1.50

Black & White Prints
S.W. Glossy Only

Oversize	$.15
Reprints	.20
Contact:	
up to 4x5	.25
5x7	1.00
8x10	1.50

Copy Work

B&W copy negative	
From 16x20 or smaller	$2.00
From 4x5 or smaller transparency	2.00
35mm color slides	
From art work or slides	Price on request

Professional Enlargement Services

Size	S.W. Glossy	D.W. Matte
5x7 or smaller	$1.50	$ 1.75
8x10	2.00	2.50
11x14	4.00	5.00
16x20	10.00

Normal Service: 4 working days.
24-Hour Rush Service: Add 100%; Minimum $5.00 extra
Quantity enlargements from same negative: Price on request
Quantity enlargements from same negative: Price on request
Enlargements made from B&W negatives up to 4x5. Normal dodging or burning-in at no extra charge. Specific or extreme cropping or dodging, add 50%.

If you hate to load 35mm film onto reels for processing, here's another way to develop film—with deep tanks, like the ones shown here at Coronado Photo; but you'll need plenty of ceiling height (or dig a pit) to allow for the tanks plus room above them to transfer films from tank to tank.

There is no extra charge for developing black-and-white film a little longer to increase the effective film speed, and, sometimes, if they make an extra enlargement or two to get one that's perfect, they'll throw in the extras at no additional charge. It's service like this, plus quality work, that has built up a good customer list over the years for the firm (Coronado Photo Co., 709 Howard St., Evanston, IL 60202). Although they do some work that comes in by mail, the vast majority is from people in the area—free-lance writers and photographers, insurance companies, a beauty-operators school, doctors, a trade journal or two, etc.

By comparison, one of the largest and most modern custom photolabs in the nation is about 40 minutes away near Chicago's Loop. Gamma Photo Labs has a 20-page price list that includes every black-and-white or color film service possible.

To name just a few:

Developing black-and-white roll film or 35mm film with a proof sheet . $2.30
Developing only of roll film or 35mm . 1.70
Enlarged proof sheet on double-weight paper: 16″ x 20″ 7.70
 (Each frame of 35mm is about 2″ x 3″)
8″ x 10″ single-weight enlargement .2.15
11″ x 14″ double-weight enlargement .4.35
50″ x 60″ black-and-white photo mural41.00

Gamma also processes color film (35mm, roll, sheet film up to 11″ x 14″—Ektachrome, Ektacolor, Kodacolor, or Vericolor); makes "ganged" contact proof sheets from color negatives; makes color or black-and-white slides from transparencies, negatives, or flat artwork; and offers a variety of color prints and enlargements: Ektacolor C, "reproduction quality" Ektacolor C, Cibachrome, "economy" color prints, and dye transfers. Want a 40″ x 80″ display transparency or a 40″ x 96″ color mural? Gamma can do that, too.

Obviously, if you're just starting out (or even years later), you can't compete with a lab like Gamma or like the other big labs in New York or Los Angeles, but you *can* set up a modest-sized lab, and offer the services that Coronado offers, and make money doing it. If your customers don't demand rush service, you can even do it on a part-time basis.

What kind of equipment will you need? Well, for developing film Coronado uses deep tanks, and Gamma uses automated equipment, but if you don't mind loading spiral film reels, you can use the same developing equipment amateurs and many pros use, only more of it. For descriptions and prices, check the annual *Popular Photography Directory and Buying Guide,* or try to borrow your camera dealer's copy of the *Master Buying Guide and Directory* published annually by *Photographic Trade News.*

At Coronado Photo they have three enlargers ready for use—a 4″ × 5″, a 2¼″ × 2¼″, and a 35mm—so they needn't waste time switching lenses, condensers, or negative carriers. They make enlargements up to 16″ × 20″.

This darkroom sink consists of a stainless steel pan with inside dimensions of 2' × 5', resting on a couple of workbenches. The right side is propped up slightly to facilitate draining. Thumbtacked to the wall above the sink, and extending into it, is a sheet of water-resistant plastic. The cost was reasonable: about $85 for the sink pan, $25 for each workbench, and $130 for the faucet and other plumbing, including labor.

Several mail-order camera dealers publish catalogs which include darkroom equipment. Among them are Spiratone, 135-06 Northern Blvd., Flushing, NY 11354; Helix Limited, 325 W. Huron, Chicago, IL 60610; and Competitive Camera, 157 W. 30th St., New York, NY 10001. The most complete catalog is published twice a year by Porter's Camera Store, Box 628, Cedar Falls, IA 50613. It's printed on newsprint, with more than 100 11½" x 17½" pages illustrating and describing just about everything you'll need to start a custom photolab—equipment *and* supplies. (The catalogs also include other photographic items ranging from adapter rings to Zip Grips.)

Professional darkroom equipment (for higher volume and/or larger film sizes) is offered by a number of firms, including: Eastman Kodak Co., 343 State St., Rochester, NY 14650; Leedal, Inc., 2929 S. Halsted St., Chicago, IL 60608; Calumet Scientific, 1590 Touhy Ave., Elk Grove Village, IL 60007; and Arkay/Apeco, 228 S. First St., Milwaukee, WI 53204. Tell them what you're looking for, and they'll send you a catalog with prices. Most of the catalogs are free; Calumet's is one dollar.

Perhaps the best way to start is small. Limit your darkroom services to just a few, until you see if the demand and profit are there. For example, you could offer the following services (for black-and-white film) only: developing of 35mm and roll film, contact proof sheets, and enlargements to 11" x 14" of negatives up to 2¼" x 3¼". That would mean that you'd need only a few developing tanks, timer, proofer, 2¼" x 3¼" enlarger (such as the Beseler 23C), two enlarging lenses (50mm and 75mm or 80mm), safelights, trays, print washer, print dryer or RC paper-drying rack, and a few other accessories—plus a darkroom sink and a darkroom, of course. Excluding the sink—which, with plumbing, might cost anywhere from $250–$1,000—the total cost of equipment could be as little as $500 new or perhaps $300 used.

You could get customers by advertising in your local newspaper, notifying camera clubs, calling on camera stores, and sending simple direct-mail pieces to professional photographers, locally edited publications, and other prospects. Before you do, however, make darn sure you're an expert at developing, printing, and enlarging! Sloppy work or, even worse, a completely botched-up job, can ruin you.

Many professional darkroom workers learn by becoming a trainee in a commercial lab, while others are self-taught or learn in high school or college. No matter what your background, it wouldn't hurt to read a few good books on the subject, such as: *The Home Darkroom* by Mark Fineman, *Photo Darkroom Guide* by Robert Hertzberg, *The Complete Art of Printing and Enlarging* by Dr. O. R. Croy, *Amphoto Home Darkroom Course* by John S. Carroll, *Photoguide to Enlarging* by G. Spitzing, *How to Use Variable Contrast Papers* by Lou Jacobs, Jr., *Enlarging: Technique of the Positive* by Jacobson and Mannheim, *Developing: Technique of the Negative* also by Jacobson and Mannheim, *Bigger and Better Enlarging* by Nibbelink and Anderson, and/or *Darkroom Techniques* by Andreas Feininger. All of these books are published and distributed by Amphoto and available through your camera dealer.

Incidentally, some of the finest darkroom workers are amateurs belonging to camera clubs. Consider joining a club and asking one of these experts to show you how he does it. Then practice, practice, practice until you're just as good, or better.

By limiting your services to only those you and your equipment can handle, you'll have control of the situation at all times and won't invest in a piece of equipment just to fill a request that may never come again. Only if a number of people ask you to make 16″ x 20″ enlargements should you invest in a 16″ x 20″ enlarging easel and 16″ x 20″ developing trays. Only if a number of people ask you to make enlarged proof sheets should you invest in an 8″ x 10″ enlarger, and so on.

From the day you start out, keep a careful record of your costs and the time you put in on each job. Your largest single expense will probably be the cost of enlarging papers, and before you standardize on one or two you should consider all the alternatives. Should you use paper that comes in different contrasts (soft, medium, hard, etc.) or a variable-contrast paper (such as Polycontrast)? Should you use a "paper" paper (Kodabromide, Medalist) or a "plastic" paper (Kodabrome RC, Polycontrast Rapid RC)? Should you buy it in 25-sheet packages, 100- or 250-sheet boxes?

Where should you buy your supplies? When you're just starting out, with few customers, you'll probably have no choice but to buy your supplies at a camera store, but shop around for the best prices and select a dealer who usually has what you need in stock or can get it quickly. Later on, though, you can save money by buying your supplies

Unless you plan to enlarge 4″ × 5″ negatives, a relatively inexpensive 2¼″ × 3¼″ enlarger such as this Beseler 23C can be used for all of your custom enlarging. Since this particular enlarger is in a low-ceiling basement darkroom, the wall paneling was extended up between the joists, in the enlarger area, to allow for the use of an extender base for huge blowups.

where the camera dealer buys *his* supplies. Surprisingly enough, a wholesale photofinisher, whom you might consider to be your competition, may actually turn out to be a good friend and welcome you with open arms, especially if he's not set up to do custom black-and-white work himself. Many photofinishers wholesale photo supplies to small camera shops, drugstores, and other retailers, and he'll probably be happy to sell to you, too, if you buy in reasonable volume. When you get even bigger, you may be able to buy your Kodak supplies directly from Eastman Kodak.

You'll also have to determine how long—from start to finish—it takes you to develop a roll of film or make an enlargement or proof sheet. At Coronado Photo, when one of the partners works alone in the darkroom, he can usually turn out an average of seven 8″ x 10″ enlargements (from different negatives) per hour. Sometimes, if the negatives are tricky to work with, his output drops to five per hour. Other times, when everything goes well, he produces ten. When two or more enlargements are ordered from the same negative, his output increases, but since the price per enlargement drops slightly, the profit remains about the same.

Using their set of deep (47 inches) tanks, each of which holds 15 gallons of solution, the partners develop an average of 25 rolls of black-and-white film every afternoon. After drying overnight, the film is cut into strips of negatives and either printed oversize (on a professional machine they bought secondhand) or printed as a proof sheet. Most of the work is ready 24 hours after it's brought in, but sometimes—especially when proof sheets are ordered—an extra morning is required. Although their price list says "four working days," most of their enlargements are ready in three days and sometimes in two.

However, if you're considering setting up a custom photolab as a spare-time venture, keep in mind that most amateurs and even many professionals wouldn't mind waiting a week for high-quality film developing or enlarging. So you could work at it only on weekends or one or two nights a week. Start small and build it up slowly. The 2¼″ x 3¼″ enlarger mentioned earlier will handle any negative from 35mm to 2¼″ x 3¼″ with the two lenses. If you see that the majority of your work is with 35mm negatives, consider getting a 35mm enlarger, perhaps a Leitz or a Durst. If numerous people ask you to work with 4″ x 5″ negatives, add a 4″ x 5″ enlarger, perhaps a Beseler, Durst, or Omega. (At Coronado they have three enlargers ready for use—a 35mm, a 2¼″ x 2¼″ and a 4″ x 5″—so they don't have to change lenses or condensers.)

Darkroom work isn't for everybody. But if you enjoy it, it's an excellent way to make money, part time or full time.

12

Store and Shop Exteriors

It's strange, but the vast majority of small-business owners have never had a photograph taken of their place of business simply because nobody ever asked them about it! Of course, if somebody *did* ask them, they might say no anyway, but this shouldn't discourage the enterprising semi-professional photographer who wants to make an extra $50–$100 every weekend. The trick is to take the photographs first, and *then* ask the business owner if he'd like to buy one.

Naturally, when you're shooting on speculation like this, you have to keep expenses as low as possible. So, your best bet is to shoot with 36-exposure rolls of 35mm black-and-white film (bulk load them yourself, to keep the cost even lower), and do your own developing and enlarging.

Wait for a Sunday or holiday when traffic is light or non-existent, or shoot early in the morning before the stores open, so there won't be any cars or trucks blocking your view of the stores. Then simply set your camera on a tripod, focus on the store at one end of the block, take a meter reading, and shoot. If the store is on the sunny side of the street, fine. Otherwise, wait for a cloudy day so you won't be shooting into the sun. Be sure to include the sign identifying the store.

Then work your way down the block, shooting each store, shop, restaurant, or other place of business in turn. If everything's working right, you'll need only one frame of film per store. When you've finished photographing one block of the business district, go on to the next, until you've finished the entire roll of film. Unless you've goofed up somewhere, this should mean 36 different photographs.

Develop the film and make one 8″ x 10″ enlargement of each on single-weight paper. Then go back when the stores and shops are open for business and show each photo to the appropriate business owner. Tell him he can have the enlargement for only $3.50, or he can have two for $6. (You can always make an extra enlargement later on.)

Another photograph of a small business. This shot was taken with a Nikkormat and a 35mm wide angle lens.

This may not be a great example of architectural photography, but it's good enough to sell to the owners or managers of retail stores, repair shops, and other businesses.

Every small business owner with a store, shop, restaurant, etc., is a prospective customer for a photo of his/her place of business. This photo was shot with a Nikkormat and a 35mm wide angle lens.

If your photographs are sharp and correctly exposed, chances are at least 50 per cent of the business owners will buy one print, and 20 per cent will also take an extra print, even those who have better camera equipment than you!

Now, what is the profit potential for you? Well, figure that a factory-loaded, 36-exposure roll of Plus-X film costs (at this writing) about $1.60 with sales tax. Chemicals to develop the film cost about 20¢. A 100-sheet box of 8" x 10" single-weight enlarging paper (not the RC kind) sells for around $20.00, so 40 sheets (4 for test strips, 36 for prints) cost $8.00, and chemicals for developing the enlargements run about $1.00. Add everything up and it totals $10.80. Add another $1.20 to cover the hot water, electricity for drying the prints, gas for your car, etc., and it all rounds out to $12.00.

So if 50 per cent of 36 business owners each buy one enlargement, that means you're selling 18 enlargements at $3.50 apiece, for a total of $63.00. Subtract your expenses of $12.00, and your profit comes to $51.00.

What about the four or five who order an extra enlargement? Well, if five do, that's five times $2.50 (the price of a second print) is $12.50. Deduct about $1.75 for paper, chemicals and gas (to make and deliver the prints), and your additional profit is $10.75. Since $51.00 and

$10.75 add up to $61.75, your profit isn't bad for a few hours of shooting, enlarging, and soliciting. If you bulk load your own film, you can make even more.

Just in case you don't care to go around afterwards and sell the prints, you can always hire a high school student to sell them on a commission basis, perhaps 35¢–50¢ on the first print and 25¢ on additional prints.

The beauty of this photographic enterprise is that you can engage in it whenever you wish and work at your own speed, in your own hometown or anywhere else you happen to be. You can even, if you wish, do the selling by mail. In this case, though, you'd be better off mailing a tiny contact print, cut from a proof sheet of the entire roll of film, together with a brief letter explaining what you've done and listing the prices. You might wish to add another 50¢ per order to cover packaging and mailing expenses, or you can hand deliver the prints when they're ready. Of course, if you show contact prints instead of enlargements, you save the cost of those enlargements which aren't sold (but when selling via personal calls, the 8″ x 10″ enlargement has more impact and usually results in more sales).

Besides the immediate profit you can make using this plan, there's always the possibility that some of the store owners will call on you when they need photos taken for various purposes. Perhaps the restaurant has a new interior, and the owner wants a photograph for his newspaper ad. The hardware store owner may want a picture of an in-store display so he can enter it in a dealer contest. The real estate man needs a steady stream of photos of new listings. If you're the only photographer they know about, it's just possible they may contact you instead of turning to the *Yellow Pages*.

What kind of equipment do you need for this plan? Not much. Just a 35mm camera—single-lens reflex or rangefinder—in good working condition, an exposure meter (hand-held or built-in), a lens shade, and perhaps a tripod, plus some darkroom equipment—film developing tank, enlarger, trays, print washer and dryer, etc., and a bulk-film loader if you go that route.

It's also possible to work the plan using color negative film and having a professional lab—the kind that caters to wedding and prom photographers—do the processing and printing. Your costs and selling prices will be higher, of course, but so might your profits.

13
Bar Mitzvah Photos

You don't have to be Jewish to take pictures of a Bar Mitzvah, but it helps if you know something about this religious ritual/family celebration, so you'll be aware of what to photograph and when to photograph it.

In case you don't have a *Random House Dictionary* handy, here's its definition of Bar Mitzvah: "A solemn ceremony held in the synagogue, usually on Saturday morning, to admit formally as an adult member of the Jewish community a Jewish boy 13 years old who has successfully completed a prescribed period or course of study in Judaism."

The dictionary also defines Bath Mitzvah: "A solemn ceremony, chiefly among Reform and Conservative Jews, that is held in the synagogue, usually on Friday night, to admit formally as an adult member of the Jewish community a girl 12 to 13 years old. . . . Also, *Bas Mitzvah*."

Actually, the boy does not have to be 13 and the girl does not have to be 12 or 13. Persons *older* than this may also have a Bar Mitzvah or Bath Mitzvah.

Encyclopaedia Britannica adds: "The boy is called up to the reading of the scroll of the Law (the Torah) . . . and after the services there is a family feast at which, in former days, the 'Bar Mitzvah' recited a learned discourse on the Law."

In *Wedding and Party Photography* (an Amphoto book published some years ago), authors Barney Stein and Les Kaplan note: "During the religious ceremony, the Bar Mitzvah boy is escorted by his parents to the altar, where a cantor chants some prayers, after which the boy usually delivers a speech."

Stein and Kaplan point out that: "Because, in the Jewish faith, the Sabbath is a day of complete abstinence from labor, there can be no photographic record of this part of the Bar Mitzvah." (Reading from the Torah.)

However, it all depends upon the rabbi and how strict is his interpretation of Judiac law. There are three main "groups" of Jews: Orthodox, Conservative, and Reform. The Orthodox are very strict, the Conservatives are less strict, and the Reform are quite liberal—and some of the Reform rabbis are more liberal than other Reform rabbis when it comes to photography. So talk with the rabbi ahead of time. Ask him what you can, and should, photograph, and when you should photograph it. If he does not permit photography during the religious services (few do), he may let you take pictures during a "run-through" just before the services, even though it's the Sabbath (which begins at sundown on Friday night and continues until sundown on Saturday night). Otherwise, you'll have to assemble the Bar Mitzvah boy, his parents, and the rabbi on some other day of the week and fake it.

Here the photographer is including a stained-glass window for a distinctive background. First determine the exposure for the window, then balance the light from your speedlight accordingly (left). If the Bar Mitzvah includes luncheon, take photographs of every guest, table by table. To get all eight or more faces in each shot, have the guests from one side of the table stand behind those on the other side (above).

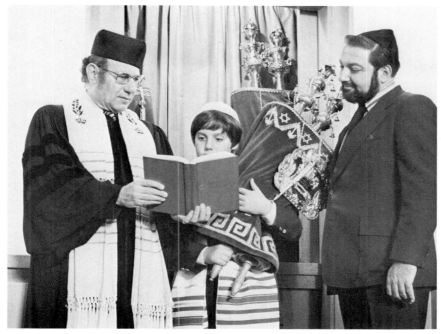

Your photographic record, presented in an album, will probably include most or all of the following: the Bar Mitzvah boy at the pulpit as he reads from the Torah and/or delivers his speech, standing before the Holy Ark (the cabinet where the Torah is stored), shaking hands with the rabbi, posing with his parents, and perhaps standing in front of the synagogue's stained-glass windows (interior photo).

If there's a luncheon afterwards, there should be shots of the boy with his friends congratulating him, members of his family each lighting one of the 13 candles on a cake, and a shot of each table of guests. Grandparents should get special photographic attention.

Other photos might show the Bar Mitzvah announcement outside the synagogue, the Bar Mitzvah boy's brother(s) and sister(s) congratulating him, and perhaps a sign outside the restaurant (if that's where the luncheon is held) congratulating him. The more shots you take, the more chances you have to sell photographs!

Like wedding photographers, many Bar Mitzvah photographers offer a standard package, perhaps 50 5" x 7" color prints in an album, for a set price and require a signed contract and a deposit before agreeing to photograph the event. A typical price (in 1976) for this package might be $195, with $78 (40 per cent) given as a deposit upon signing the contract, perhaps another deposit a few days before the event, and the balance due upon delivery of the proofs. Additional prints are offered at various prices, depending on size and, sometimes, the quantity ordered per negative. The contract spells everything out, including: "Proofs are the property of the studio and are loaned for selection purposes only. Proofs must be returned and final order placed within 40 days after receipt of proofs."

To see exactly what Bar Mitzvah photos should look like and what the contract should say, find a few people who have had a Bar Mitzvah in their families recently and ask to look at the photos and the contracts. This will tell you the prevailing prices in your area, too.

Today, almost all Bar Mitzvah photographers use either a 35mm or a 2¼" camera (Nikon, Canon, Pentax, Rapid Omega, Mamiya Universal Press, etc.) and color negative film, with a single speedlight (usually a heavy-duty job with a separate power pack) that recycles in a couple of seconds. They may also take a few photos with available light, especially those that include a stained-glass window or candles. Some process their own film; most send it out to a commercial lab.

Professional photographic magazines such as *Studio Photography* (250 Fulton Ave., Hempstead, NY 11550) and *The Rangefinder* (3511 Centinela Ave., Los Angeles, CA 90066) carry ads for labs that specialize in this type of work. For example, Nationwide Color Service (Beloit, KS 67420) will process a roll of 120 or 20-exposure 35mm Kodacolor II or Vericolor II film for $1.10, or a roll of 220 or 36-exposure 35mm for $1.85 (1976 prices, without prints). If you want color prints at the time of processing, it's 25¢ for a 3½" x 5", a 4" x 5", or (from a 2¼" x 2¼" negative) a 5" x 5". These can be used as proofs.

After your customer looks over and selects from the proofs, the lab will make "candid prints—available only from negatives of an event such as a wedding, Bar Mitzvah or party" for 50¢ (2½" x 3½"), 65¢ (3½" x 5"), 70¢ (4" x 5"), 80¢ (5" x 7"), $1.25 (8" x 10"), or $3.80 (11" x 14").

These magazines also carry ads for manufacturers of albums, plaques, gold-stamping machines, pricing guides, lens attachments (for vignettes or montages), and other professional photographic items.

So if you're looking for a way to make money in photography, and have the Sabbath free, consider Bar Mitzvah photography.

Mazel tov!

14

Photos
for Newspaper Ads

When a national advertiser spends in excess of $50,000 for a page of advertising in *Reader's Digest* or *TV Guide,* it's common to spend anywhere from $2,000–$10,000 for the photographs in the ad—which is why there are a lot of high-priced photo studios serving the ad agencies in New York, Chicago, and a few other major cities.

However, when a small retailer or service business buys $50–$200 worth of ad space in a local newspaper, it's only natural that the photography budget be modest, too—which is why there's an opportunity for free-lance photographers to make some extra money taking pictures for local newspaper ads.

As I'm writing this, I'm looking through three recent issues of a weekly tabloid newspaper published in a Chicago suburb to see exactly what kind of photos are appearing in ads and also which ads might be improved if photos were in them. I won't list all of them, but here are some of the advertisers using photographs: an insurance company (seeking additional employees), a furrier, a jeweler, another furrier, a garden center, a savings and loan, a new condominium, a private school, a knitting shop, a shoe store, a funeral home, a luggage shop, a decorative hardware store, a custom drapery shop, a store selling fireplace accessories, and numerous real estate firms.

Among the ads without a photo are those for: a large hardware store, a store specializing in exercise equipment, a catering service, an art supplies store, a new shop specializing in yogurt, a hotel, and a "furniture clearance center."

In my opinion, the ad for the large hardware store would have been more effective had it contained a photo of the store interior to show its extensive inventory. Similarly, the ad for the art supplies store should have included a photo of its large stock of picture frames (which covers a 40-foot wall from floor to ceiling). The yogurt shop ad could have shown people of all ages enjoying yogurt, along with a view of the store

interior, and the ad for the catering service might have included photos of typical buffet and sweet tables.

However, whether advertisers presently use photographs or do *not* use photographs, just about every one of them is a potential client for the enterprising free-lance photographer. Even if a store consistently uses photos supplied free by manufacturers, there's still an opportunity, in many cases, for a local photographer to take the kind of photos the manufacturers *cannot* supply: photos of the store's exterior, the store's interior, special departments in the store; the personnel in the store; and/or photos of local people modeling products the store sells.

Many times, too, a store needs a good black-and-white tabletop photo of a certain item for an ad, and the manufacturer either cannot supply the photo in time or has only a color print or a printed piece (which may not reproduce well). Maybe the store wants to feature, in one photo, products from a number of manufacturers.

Even if a local advertiser is presently using photographs that were obviously shot especially for their ads, they may be looking for *another*

With very few exceptions, any business that advertises in the local newspaper could use photographs in its advertising. The photo on the left, showing a floor-to-ceiling selection of slacks, was taken for a men and boy's clothing store. Taken with a Nikkormat with 35mm wide-angle lens with available light. To illustrate the effectiveness of a polishing cloth, a silver dollar was artificially tarnished, then half of it was polished with the cloth. This photo could be used by a hardware store. Taken with a Rolleiflex with close-up lens attachment, using two floods (below).

Bookstores frequently use photos in their ads—as many as a dozen at a time. Problems may develop, though, when you're trying to photograph a book jacket with difficult colors—black printing on a blue background, for example. Try a filter to lighten one of the colors. This photo was taken with a Rolleiflex and one floodlight, with the book on a seamless paper background.

photographer, one who is better, faster, more dependable, and/or less expensive.

How do you get started in this business?

Naturally, you must first have the ability, the equipment, and the time to do the kind of work you want to specialize in. I say "specialize" because it's often better to specialize in one area—tabletop shots, fashion photography, store interiors, etc.—than to try to be a jack-of-all-trades, especially if you're doing the work in your spare time and have only a limited budget for equipment.

Select a specialty, take enough photos to become fairly proficient at it, and then make up a sample portfolio of about two dozen different photos. Take these around to the managers (or ad managers if the advertiser is large enough to have one) of the businesses advertising in your local paper, and tell them how much you charge. Don't price yourself too low, or you'll lose money on every assignment, nor too high, or no one will be able to afford you. Perhaps $10–$25 per photo is a good range, with the exact price depending on how much time and expense is involved in getting the photo.

Also, call on the advertising manager of the newspaper, who is in weekly contact with most of the advertisers. He may be willing to act as your unpaid sales representative, since your photography may mean the difference between a business advertising and not advertising. Although the staff photographers on many newspapers frequently take photos for ads, either as part of their regular job or while moonlighting, others don't care to bother with it or are just too tired after running around all day for spot news or feature pictures.

Taking photos for newspaper ads is not only interesting work and fairly lucrative, it's a great way to build up a portfolio should you ever decide to go into advertising photography on a full-time basis.

For more information, see the chapter on small-product photography, and study a few appropriate books such as *How to Make Money in Advertising Photography* by Bill Hammond, *The Studio* (from the *Life Library of Photography*), and *Photography for the Professionals* by Robin Perry.

These plaques honoring Beethoven, Bach, and Brahms were photographed for an ad run by a music store. Taken with a Rolleiflex, using two floods (above).

15
Wedding Movies

Would you like to make up to $50,000 a year or more taking movies of weddings? It's quite possible, according to two Illinois men, and they'll even show you how to do it.

However, before we discuss their plan, let's lower our sights a bit. How would you like to make up to $10,000 a year or more taking movies of weddings? That's a more realistic figure for the spare-time photographer who has only his weekends free, and to make that $10,000 a year, all you need do is film one wedding on Saturday and another wedding on Sunday, make $100 profit on each, and keep it up all year long.

Of course, this is easier said than done, but it definitely *is* possible, it's not that difficult once you know how, and you can probably make *more* than $100 profit per wedding.

Wedding movies are not new. When I got married back in '56, I hired a professional to shoot 16mm color movies of the event. They were silent movies because sound was impractical in those days, but we still enjoy looking at them every now and then, and I know that other people have professional wedding movies that are even older.

Notice I said "professional." Lots of amateurs take movies at weddings, but comparing the average amateur film to a good professional's is like comparing the average snapshot to the photos you see in *National Geographic*. A professionally photographed wedding movie has or should have steady camera work, perfect exposure, titles, pacing, close-ups as well as long shots, perfect focus, smooth zooms, and, most important, it should capture all of the highlights of the wedding.

These highlights include the wedding party walking down the aisle; the bride and groom taking their vows; the newlyweds kissing and then walking up the aisle; the couple being introduced for the first time as Mr. and Mrs. as they enter the reception hall; the receiving line; a toast or two; the cake cutting; the bridal dance; the bride tossing the

Film the receiving line from both sides to show the bridal party and also some of the guests.

Unless you're filming just the highlights, include the guests at each table. You can film these silent and add music later.

You can make a lot of money filming weddings—if you know what you're doing. You can use single-system sound cameras like the one shown here, or, better yet, a double-system set-up.

bridal bouquet; and the newlyweds taking their leave. If you keep each scene short enough, you can squeeze all that—plus a couple of titles— into 200 feet of film. At the usual 18 frames per second, this runs about 13 minutes. If you're asked to include all the guests, more dancing and singing, or other action, you'll need another 100 or 200 feet of film, maybe more.

How much should you charge? Well, if you use a single-system super 8 sound camera (the kind now being sold in every camera shop, department store, and discount house), you'll naturally need magnetically striped super 8 film. For a 200-foot film, if you don't edit out any footage, you'll need four 50-foot cartridges of either Kodachrome or Ektachrome. Let's say you use Ektachrome 160, which is much faster (and a bit grainier) than Kodachrome. The last time I checked, the

discounted price per cartridge was about $6.00, plus about $3.00 for processing. Multiply that by four, and your 200-foot film will cost around $36.00, plus another $1.50 or so for a reel and can. Add the cost of photoflood bulbs, travel expenses, and other odds and ends, and your out-of-pocket costs will probably come to around $45.00, but let's say $50.00, to cover the usual annual increase in film and processing costs and unforeseen expenses (e.g., parking-lot charges). So if you charge $150 for the movie, your profit is an even $100. Actually, $150.00 is darn cheap for a wedding movie in color and with sound, so try for $250.00 or even $300.00. (Often, much more than that is spent just for the flowers.)

However, all that profit, for five or six hours' work, is not *clear* profit. You must take into account your investment in equipment and the film you'll waste in practice. Although there is, in the U.S., an average of one divorce for every two marriages (in 1975 there were approximately 1,026,000 divorces and 2,126,000 marriages), almost all wedding movies are of first marriages, and you'll need plenty of practice to help make sure you won't screw up. Offer to film a few weddings for free, or for just the cost of the film, with the understanding that you're starting out in the business and the films may not turn out. (Don't pass yourself off as a professional until you *are* one.)

As for equipment, if you go with single-system sound (where you use magnetic-striped film, recording the sound on the film as it goes through the camera), there are new cameras and projectors coming on the market every few months, so I can't suggest any particular brand or model. Ideally, to avoid having to change film at inopportune moments, you camera should accept 200-foot rolls of film. Unfortunately, almost all of the super 8 sound cameras accept only the standard 50-foot cartridges. (Some of those that *do* take 200-foot rolls lack some features you should have.)

Your camera should have a high-quality zoom lens that focuses close and has a speed of about $f/1.2$; filming speeds of 9, 18, and 24 frames per second, with a slow-motion speed as an added bonus; through-the-lens viewing and focusing with a split-image rangefinder; through-the-lens metering with full manual override; provision for fade-ins, fade-outs, and lap dissolves; an accurate, easy-to-read footage counter (a frame counter would help, too); a built-in meter to measure battery strength; easy loading; and rugged construction.

You'll also need a good microphone or two with extension cords; one or two 1,000watt lights (photoflood or, better yet, quartz) with tall, heavy-duty stands and extension cords; a tripod and/or a chest support; a hand-held exposure meter (to double-check the camera's); extra film and batteries; and, if possible, a second movie camera with an operator.

When the film is back from the lab, you'll need a super 8 magnetic sound projector—one that records as well as plays back sound (so you

Cutting the wedding cake and then testing the first piece are other "must" scenes.

can add music or narration); a projection screen; an editing system with a splicer and a viewer that lets you hear the sound as well as see the picture, frame by frame; and a few other accessories, such as some titling equipment.

You can probably buy all this for under $1,000 or for under $2,000, if you want top-of-the-line equipment.

There are several problems with single-system sound, which is why most pros don't use it. With magnetic-striped film, the sound is recorded 18 frames ahead of the corresponding picture. So if you want to edit the film (e.g., to cut out an under-exposed or out-of-focus shot), it's difficult and sometimes impossible. If you cut to the picture, you lose the sound that's on the preceding scene and include sound from the following scene (which you may want to move somewhere else). If you cut to the sound, you include some frames you don't want and lose some you do. Also, every time you start and stop the camera, you start and stop the sound. So if you're filming the dancing while the orchestra plays, and want to cut from a long shot to a close-up, the music sounds jerky; and if you splice the film, you can hear the splice when you project the movies.

Be alert for the first kiss as Mr. and Mrs. and the other "traditional" scenes. List them all so you don't forget any.

Outdoor portraiture of children whether in color or black-and-white is a challenge, but it can be financially rewarding. I photographed this two-year-old in a block-square wooded area in the middle of town, using a Nikkormat with a 200mm lens, Kodachrome film, 1/125 sec. at f/5.6.

Since few photographers specialize—or even take—pet portraits, the field is wide open. I photographed Charlie, our Welsh Terrier, with a Canon and a 135mm lens, using three speedlights, Kodachrome film, 1/60 sec. at f/11.

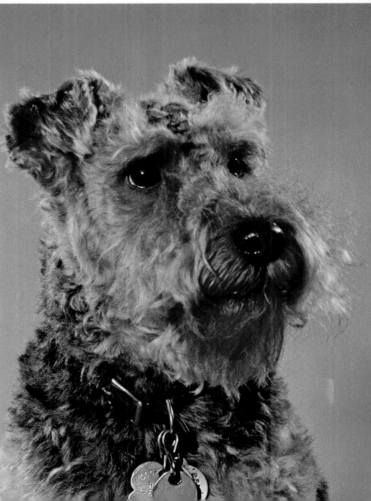

Advertising postcards and brochures for resorts, motels or recreational land developments should include photos of people having fun. But make sure you have model releases. Taken with a Nikkormat and a 35mm lens, Kodachrome film, 1/250 sec. at f/8.

This action shot of a high school football game was not shot from the sidelines, but from behind a fence. The 200mm lens on my Nikkormat did the trick. Ektachrome film, 1/500 sec. at f/8.

Aerial shots are often used by real estate firms to show prospective clients where a property is located relative to roadways and waterways. This shot was taken with a Nikkormat and 24mm lens, Kodachrome film, 1/500 sec. at f/4. Photo by B. Sastre.

San Francisco's Golden Gate bridge has been photographed thousands of times, but not many pictures have included these flowers which may be a selling point to illustrate a travel article. For depth of field, I needed the 35mm lens on my Nikkormat, Ektachrome film, 1/60 sec. at f/16.

Another example of outdoor child portraiture, taken in a forest preserve a few miles from the city, using a Nikkormat and 35mm lens, Kodachrome film, 1/60 at f/8.

Also watch for scenes like this one—the bridegroom's mother wiping away a tear after the ceremony.

For those reasons, and others, Marv Goldman and Howard Goone of Movies to Remember Studio (4448 West Oakton Boulevard, Skokie, Illinois 60076) use double-system sound for super 8 wedding movies. Goldman started filming weddings (in 16mm) about 17 years ago, and since then he and free-lance cinematographers working for the studio have filmed more tha 3,000 weddings (once they covered 19 in one day). For the past several years, the studio has been using super 8 color film almost exclusively.

"When I go out on a job," Goldman told me, "I take with me one or two silent cameras—usually a Canon or a Bolex—loaded with Kodachrome, more extra film than I think I'll need, a chest pod to support the camera, a cassette tape recorder with 120-minute tapes, and a mike with a long cord—I tape the mike to the P.A. mike stand—and a 1,000watt quartz light on a heavy-duty stand, plus about 200 feet of extension cords for the light, and a few other accessories.

"I usually bounce the light, and most of the time I shoot at $f/4$. When I have to shoot with just the available light—say, from the balcony of a church during the ceremony—I open the lens all the way to $f/1.4$ or $f/1.2$, and film at the usual 18 frames per second. If there still isn't enough light, and if there isn't too much action going on, I shoot at 9 frames per second, which is equivalent to opening the lens another full stop.

"I usually keep the tape recorder going all the time, turning the cassette over or changing it every hour. If I do stop and start the recorder, I have a set routine—first the sound, then the light, then the

camera—that I follow so I won't forget anything. It's a lot easier to edit the tape than to edit the film, and I have no trouble matching up the sound with the picture later on.

"When I get the films back from the lab, I cut out any bad parts—there usually aren't any—splice the films in sequence, add an opening and a closing title, add a magnetic track—I have equipment for doing that—and then I'm all set to add the sound. After I edit the tape, I re-record it onto the magnetic track, along with some wedding music from another tape.

"To make a 53-minute film—that's 800 feet—takes me a total of about six hours. That includes filming time and editing time. We charge $1.50 a foot, $1,200.00, for an 800-foot film. Our minimum is $325.00 or $350.00—it depends on what's involved—for a 200-foot film.

"It may sound easy, but it took me 17 years to develop and perfect this system, and now I'm ready to show others how to do it—how to make up to $50,000 a year filming weddings. We'll supply all the equipment, train people here and on location, process the film, edit it, and sync it—for a reasonable fee, of course. I'll be happy to supply the details to anyone who writes me."

Whether or not you write to Marv Goldman, there are a few publications that can give you more information about movie-making and/or weddings. These include *Petersen's Guide to Movie Making* by David MacLoud and the editors of *Photographic Magazine; Modern Wedding Photography* by Suzanne Szasz (it's about still photography, but it can help nevertheless); Kodak's *How to Make Good Sound Movies* and *Home Movies Made Easy;* and *Super-8mm Movie Making Simplified* by Myron Matzkin.

16
Photographing Amateur Athletes

If a person is good at a sport, he's proud of it, and if he's proud of it, chances are he'd like a photograph of himself in action.

That's why you can make good money photographing amateur athletes, even if other photographers are in abundance!

Take high school or college football, for example. At any game you'll see up to a dozen or more photographers on the sidelines and up in the press box. Whom do they photograph? Usually, they photograph only the quarterbacks, the ball carriers, the defensive tackles, and the kickers. What about all the *other* players on the field and the team members who rarely get a chance to play? They're *eager* to buy photographs of themselves in action, even if the action is only during practice sessions.

The same thing holds true for members of other teams—baseball, basketball, soccer. Some players are photographed at every game, while others never have a lens pointed in their direction.

Of course, don't neglect the stars. Some of them will buy every photo of themselves they see. However, it pays to concentrate on the second- and third-stringers—the bench-warmers who are usually more than willing to purchase some sign of recognition, something they can cherish when they're over the hill.

There are dozens of different types of amateur athletes and outdoor sportsmen you can photograph for pay, and not all of them are on teams. Here's a partial list of their activities: the above-mentioned football, baseball, basketball, and soccer; ice hockey; tennis; track and field; golf; skiing; water-skiing; motorcycle racing; snowmobiling; motorboat racing; boxing; wrestling; badminton; croquet; surfing; sailing; bowling; figure skating; tobogganing; fishing; high diving; scuba diving; hunting; skeet shooting; bicycling; swimming; archery; target shooting; mountain climbing; horseback riding; canoeing; rodeo competition; spearfishing; skateboarding; fencing; handball; sailplaning;

To cover sports events, a press pass is desirable, but you can still get good pictures without one, like this action shot sneaked from the stands. This one was taken with a 200mm telephoto on a Nikkormat.

hang-gliding; racquetball; and curling. You can probably add a dozen more.

Pick one of these activities (preferably one you're engaged in personally) and specialize in it. The more you know about a sport, the better you can anticipate the action, and be at the right place at the right time to capture it on film. If the activity you select happens to be one (like football) that requires a press pass in order to be at the right place, either select another activity, do your best with a telephoto from the spectators' area, or pass up the college games and perhaps even the high school varsity games in favor of the high school sophomore games, where they're not too particular about who can shoot from the sidelines. Try to get a press pass by giving or selling your photos to a newspaper, magazine, or school yearbook.

To some extent, the activity you select determines the camera equipment you should use, but you can photograph most sports activity with a 35mm or 2¼″ camera with a short telephoto and, preferably, a motor drive or rapid winder. Many indoor events can be shot with available light, but sometimes a speedlight (or, better yet, two speedlights—with one as a slave extension) can improve your pictures.

For more information on photographing sports, see if you can find a copy of any of the following: *How to Photograph Sports* by Jack Sheedy and George Long (distributed by Ponder & Best, Inc., importers of Vivitar and Olympus equipment); *Guide to Photographing Sports* by Mark Kauffman (out of print, but try your public library); *The Spectacle of Sport from Sports Illustrated* (also out of print); or *Focus on Sports: Photographing Action* by Richard Turner (Amphoto, 1975).

What you charge for the photographs is up to you, of course, but $4 or $5 for an 8″ x 10″ black-and-white of a high school or college athlete seems about right, and $5–$10 for a photo of an adult bowling, playing tennis, or whatever, is about as much as the traffic will bear in most

cases. However, if you happen to catch a once-in-a-lifetime shot of a spectacular high dive, ski jump, or other feat, don't hesitate to ask for more; and don't forget that multiple sales are often possible. Each member of a team is likely to buy a team photo, and an individual may buy a quantity of prints of himself for his home, his office, and to send to relatives and friends.

You may also be able to sell some of your photos to local newspapers, school publications, lodge bulletins, house organs, or other publications. *(See the chapter on feature and news photos for newspapers.)*

Another way to make money in this field is to shoot a sequence of still photos or slow-motion movies of golfers, high divers, bowlers, etc., so they (or an expert) can analyze their movements. You can purchase a super 8 movie camera with a slow-motion filming speed of 54 frames

At a football game, the quarterbacks are among the most photographed players. This one was shot with a Canon and a 135mm lens, on Tri-X, at 1/250 sec. and f/5.6 on a dull day.

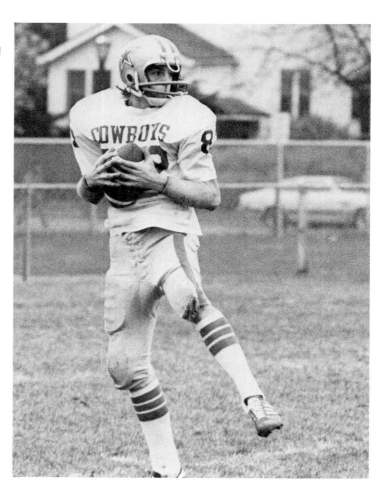

per second for $700–$1,200, and a super 8 projector with a 3-frame-per-second setting for as little as $225; the 54-frames-per-second filming speed together with the 3-frame-per-second projection speed should give you all the slow-motion you need. You can invest $2,000 or more and get yourself a Hulcher camera, which exposes 35mm film as fast as 65 frames per second, with each frame far sharper than a movie frame because the camera has a high-speed shutter. For these analysis photos, you can charge $25, $50, or perhaps even more per sequence—plus expenses. (Those slow-motion and rapid-sequence cameras can really eat up the film!) You'll find more details in *How to Make Sports-Analysis Films,* available from Kodak at $2.65.

If you like sports—and even if you don't—you *can* make money photographing amateur athletes and outdoor sportsmen and sportswomen.

Another tough subject is indoor tennis. This amateur player was photographed with a Canon and Tri-X, at 1/125 sec.

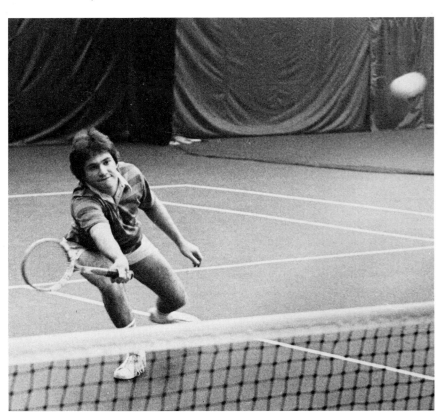

17

Illustrations for Trade Journals

Ever hear of *Western Outfitter, American Coin-Op, Fence Industry, Military Market, Food Marketer, Fire Engineering, Emergency Product News, Pest Control Magazine, Seaway Review, Medical Dimensions, Hardware Age,* or *Selling Sporting Goods?*

All of the above are trade journals (magazines for people in a specific business, industry, trade, or profession), and all of the above pay fairly good money for black-and-white or color photos. (Some trade journals, though, pay only $2 or $3 per photo—not enough to cover the cost of film, processing, and postage.) These photos are usually purchased to illustrate an article—one the magazine already has or that you, as a writer-photographer, are supplying—but many trade journals buy photos alone for cover use or for inside use with captions.

The best way to find out about the photo needs of trade journals is to read the latest edition of *Writer's Market,* an annual prepared by the publishers of *Writer's Digest* magazine. (Your public library or bookstore may have it.) The 1977 edition lists more than 600 paying markets in its "Trade, Technical and Professional Journals" section, which is divided into 85 categories ranging from "Accounting" to "Water Supply and Sewage Disposal."

Not all of these publications buy photos, but enough of them do to make a study of *Writer's Market* worthwhile. Perhaps the best way to break into the trade journal field is to start with the publications you may already be reading.

Let's assume you are *not* a full-time free-lance photographer, but make your living doing something else. Maybe you work in a camera store or photofinishing plant; if so, you may be a reader of *Photo Marketing.* This trade journal runs articles about camera stores and photofinishing plants, highlighting unique features, promotional programs, special problems, and other aspects of interest to its readers. Is there something interesting you can write about and take pictures of where

you work? *Photo Marketing* may pay you 6¢ a word and $5–$7 per published photo for your submission. (Don't worry if you're not an accomplished writer. Trade journal editors are accustomed to doing a lot of rewriting.)

Perhaps you're in the food retailing business and read *Progressive Grocer.* If so, it shouldn't be too much of a problem for you to prepare and send in what the editor wants: "Tight, direct, informal, colorful writing . . . on supermarket merchandising, success stories, consumer relations, promotional campaigns, or people in the business." On acceptance, they'll pay you a minimum of 5¢ a word, and $15 for black-and-white or $25 for color photos, with captions.

Are you an employee in a florist's shop? *Florist* runs brief articles on shop management and sales promotion, for which they pay 5¢ a word and $5–$30 for black-and-white or color photos.

Start by writing about—and photographing—a subject you already know, and by studying—not simply reading—the magazines in your field. See what kind of photos they use. Action shots of people at work? Interior views of an entire store or production line? Close-ups of products or people?

This shot (above) was taken to illustrate a magazine article on a camera store that does its own black-and-white photofinishing. Taken with a Nikkormat with 35mm lens. Illustrating a story about a new floor display, this photo was taken at a beauty shop, using a Rolleiflex (right). One floodlight supplemented the natural light.

Symbolizing eye protection—carried to the extreme—this suit of armor is on display at an optical firm in Chicago. Taken with a Nikkormat and 35mm lens, with available light.

If you (or your employer) are not a subscriber to a particular trade journal, but you think you might be able to sell them some photos, see if your public library subscribes so you can study the publication. Or ask someone in the business if you can borrow a few copies. Many of the trade journals will send you a sample copy—free or for one dollar—by requesting one on stationery that states you're a free-lance photographer.

If there are no trade journals in your field, or if you want to increase your potential market area, go through *Writer's Market* and see which trade journals do not require any special expertise on the part of contributors.

For example, *Bicycle Journal* wants 200- to 300-word stories (one sheet of double-spaced typing) about dealers who service what they sell—stories of a single, outstanding feature of a bicycle store, such as an attractive display or an unusual sign, a sales or service tip, or an interesting store layout. For an 8″ x 10″ black-and-white vertical photo, they pay $32.50–$37.50, which isn't bad for one shot and a little typing—and you don't have to be an expert on bicycles.

Similarly, *Golf Shop Operations* pays $10 for black-and-white photos showing how pro shops promote, merchandise, and display golf equipment; *Ski Business* pays $10 for black-and-white shots of sales or rental techniques; *Office World News* pays $10 for black-and-

white photos to illustrate articles about independent office products dealers; and *Campground Merchandising* pays $10 for black-and-white pictures of recreational vehicle campgrounds that sell equipment and merchandise to RV'ers.

Naturally, you can't get rich selling photos at $10 apiece if you go out *specifically* to shoot those pictures. However, if you carry a camera wherever you go (and perhaps keep a tripod and some lighting equipment in the trunk of your car), chances are you're bound to come across numerous photo opportunities during the course of a week or two. Just keep your eyes open when you go shopping or drive through town, when you're out dining or on vacation, or when you're traveling on business. With just an ordinary camera (preferably a compact 35mm, so you won't mind carrying it everywhere) and a roll of black-and-white film, you can conceivably shoot enough pictures to make an extra $50 or more per week, with little effort. Don't forget to ask for details about whatever you're photographing, so you can write captions or short text pieces, and be sure to identify any people in your photos, with their names spelled correctly.

Once you start selling photos to trade journals, the editors are likely to give you photo assignments when they need a photo of something in your area. Also, they may ask you to shoot color transparencies for cover use, which pays considerably more. For instance, *Physician's Management* pays $75 a page for black-and-white photos purchased with or without an article, $100 a page for color, and $250 for a color photo used on the cover. *(For more details, see the chapters on magazine covers and house organs.)*

I took this shot at a gun-rental firm on the grounds of Paramount Studios in Hollywood for a gun magazine. This particular photo was taken with a Rolleiflex, which I also used for color transparencies, while others were taken with a Nikkormat.

18

Showing Movies at Parties and Meetings

About once a month, a high school girl in the Midwest runs the following classified ad in a local weekly newspaper, under the "Entertainment" heading:

BIRTHDAY PARTY FUN!
Sound, color cartoons and comedies shown in your home. All ages love 'em. Creature and full-length features, too. Our 8th year—lowest rates. (Her name and phone number follow.)

At $1.60 per line, the seven-line ad costs her $11.20, which she quickly recoups before her first booking is over. She charges $25 for an hour-long show, and each time she runs the ad she gets between 10 and 15 bookings, which is all she cares to handle per month.

She grosses between $250 and $375 a month. Since her only costs are the classified ad, car expenses, minor maintenance on her 16mm sound projector, and about $35 a month toward the purchase of additional films, her profit averages out to more than $15 per working hour.

Incidentally, she inherited the business from an older brother, who started it eight years ago when *he* was in high school. At the present time, her film library consists of about eight feature films, 20 color cartoons, and a dozen comedies (Buster Keaton, Laurel and Hardy, Abbott and Costello, Three Stooges, etc.).

Obviously, showing movies can be quite profitable, but unless you happen to have an older brother willing to pass on the business to you, an initial investment—ranging from about $500 to several thousand dollars—is usually required.

On a more elaborate scale, a man in Illinois operates a full-time film service, and runs the following ad in the *Yellow Pages* under "Motion Picture Film Libraries":

(The name of his company)
● 16MM SOUND MOVIES ●
Children's Parties a Specialty
Schools ● Churches ● Organizations
Film Rental or Complete Projection Service
Cinemascope Lenses & Large Screens
Equipment Rental—Call Any Time
● Xmas Films ● Color Cartoons
(His address and phone number)

His rates vary, depending on which films a customer rents (by the day), whether a sound projector is rented, and whether a projectionist goes along with the projector. For example, 16mm sound color cartoons rent at $4–$10 each, depending on length. A 45-minute "Spook Spectacular" promoted during the Halloween season rents for $50; it includes five nine-minute excerpts from horror movies such as *Son of Frankenstein* and *Creature from the Black Lagoon*. If a sound projector is needed, it rents for $20 a day, plus $7.50 for a screen, and if a projectionist is needed, that's another $35 for a one-hour screening.

The easiest, and least expensive, way to start is to specialize in showing movies at children's parties. For the average party held in the rec room of a house or the living room of an apartment, a super 8 sound projector should be adequate. Get one with a zoom lens, so that the projected image will fill the screen at almost any projector-to-screen distance.

A super 8 sound projector with zoom lens will cost you, new, between $235 and $500, depending on make and model. I suggest you get one that will record, as well as play back, sound so you can prepare a brief introduction custom-made for every party. All you need is a few feet of magnetic-striped movie film showing a birthday cake or other birthday scene—one that doesn't show any names, faces, ages, or dates. First, record a musical fanfare. (You can buy a record album of sound effects for $15.) Then, before each party, add a brief voice-over track announcing something like this: "And now, in honor of Lisa Johnson's fifth birthday, you're invited to settle back and enjoy an hour of fun with Abbott and Costello, Popeye, Charlie Chaplin, and the Monster from under the Sea!" Splice this strip of film to the beginning of the reel for a special, added effect.

A 60" x 60" projection screen, with a stand, will cost around $60. Figure another $42 for a sturdy but portable projector stand, and perhaps $5 for an extension cord. A super 8 splicer and rewinds add another $30–$80 (depending on how elaborate a splicer you want), and

For large groups—and long throws—you'll need a 16mm sound projector like this one, but a super 8 projector can be used for smaller gatherings in homes or apartments. Taken with a Canon and a 50mm lens, with available light.

figure in another $50 or so for extra projection reels and cans, projection bulbs, film cleaner, and other odds and ends.

Now for the films themselves.

You can buy them new or used, or you can rent them as you need them. New films are produced in super 8 by nearly a dozen suppliers, including Castle Films, Columbia Pictures, Atlas-Sterex and Eumig (U.S.A.). For example, a Three Stooges film from Columbia—400 feet of super 8 sound, in black-and-white—lists for $32.50. A Walt Disney animated film—in color and sound—lists for $29.95 and runs about nine minutes. With super 8 sound film projected at 24 frames per second, figure 72 frames or three seconds of running time per foot. Thus, a 50-foot movie runs for 150 seconds or 2½ minutes, and a 400-foot film runs for 20 minutes.

The selection of super 8 sound movies is getting bigger every year. Castle Films alone offers more than 150 films in this size, including science fiction, comedies, cartoons, sports, action-adventure, and newsreels. Castle and other companies also offer excerpts from Hollywood feature films—recently issued movies as well as those dating back to Hollywood's earliest days.

With the super 8 equipment mentioned above, and a reasonable assortment of films appealing to various age groups—pre-school, kindergarten through second grade, third grade through fifth, etc.—you can start earning pretty good money in your spare time by showing movies at children's parties.

You do *not* have to buy everything new. Used super 8 sound projectors are available at many camera stores, or you can check the classified ads in your local newspaper. The same goes for films, although sound films—being relatively new—may be hard to find. You might try a "Wanted to Buy" ad and offer 25–50 per cent of the new price.

If you want to expand your business and show films for clubs, churches, business meetings, or other groups, you'll have to invest in a 16mm sound projector. Not only is there a wider range of 16mm films available, but 16mm equipment is better suited to the longer projection throws required when you're showing films to larger groups. New, a 16mm sound projector will cost between $500 and $750, or as much as $1,350 if you want one that will record as well as play back magnetic sound. (The others play back optical sound.) Used projectors are fre-

quently available at half or three-quarters of these prices. Add another $95 for a 70" x 70" screen, and $100–$200 for rewinds, a splicer, extra reels, and cans, etc.

Naturally, 16mm films cost more than super 8 films; they're offered by Castle Films and others. As an example, National Cinema Service (New York City) sells Popeye cartoons—750 feet, in sound and color—for $85 each, or 400 feet of Superman color cartoons for $59. There are 40 frames per foot of 16mm film. Projected at the sound speed of 24 frames per second, this means that a 400-foot reel runs about 11 minutes. Most 16mm sound projectors will accept reels up to 2,000 feet in capacity, so one reel of film can run for nearly an hour.

The most unusual catalog of 16mm films is available (for $4.95) from Films Incorporated, 1144 Wilmette Ave., Wilmette, IL 60091. Called *The Last Whole Film Catalog*, it lists and describes several hundred motion pictures in a complete range of categories, including adventure, allegory, animal life, animation, comedy, fantasy, health, history, literature, and sports. The films may be rented (at $15–$100.00) for one showing "if no admission is charged" or purchased ($90.00 and up).

The best collection of old-time movies—plus modern films—can be found in the catalog of Blackhawk Films, 1235 W. 5th St., Davenport, IA 52808 (send one dollar). Here—in 16mm optical sound, super 8 silent and/or super 8 magnetic sound—are many of the films made by Charlie Chaplin, Laurel and Hardy, W. C. Fields, Buster Keaton, Ben Turpin, Mack Sennett, Charley Chase, Fatty Arbuckle, D. W. Griffith, Mary Pickford, and Pearl White (*Perils of Pauline*), among others. You can also find films of the 1933-34 Chicago World's Fair, Coney Island in the early 1900's, and a tour of a Hollywood movie studio in 1922. The films are for sale at various prices from $3.97 on up into the hundreds of dollars.

Perhaps the easiest and least expensive way to start a service catering to clubs and business groups is not to provide any films at all, but just a sound projector, a large screen, and a projectionist. A charge of $25–$40 for an hour-long showing is about average. You can offer to obtain some of the free films that are available to groups from the telephone company, stockbrokers, fund-raising organizations, industrial companies, and others. For a free catalog, write (on the letterhead of some organization) to Modern Talking Picture Service, 2323 New Hyde Park Rd., New Hyde Park, NY 11040.

Showing movies, from either your own film library or someone else's, *can* be very profitable, and don't despair if you can't even afford to buy a used projector. If you want to get started in this business with the least possible investment, try your local public library. Mine will rent out a 16mm sound projector, for 48 hours, for only $5, or a super 8 sound projector for just $3, and a screen for only a dollar more!

19
Indoor Portraits of Children

It's almost impossible *not* to make money taking photographs of children. Most parents are so eager for a photograph of their child (especially the first child) that they'll often pay good money for bad pictures simply because a certain photographer got to them first and promised them a bargain price. If you're interested in this kind of 99¢ portraiture, check the help-wanted ads and get a part-time job with a commercial outfit doing this kind of work. The pay is fair, but you'll have to race all over town and be in and out of a home in 15 minutes— and the photos look it.

If you're in photography for the enjoyment as well as for the money, I suggest you go the quality route. To paraphrase John Ruskin (whose words are quoted on the wall of every Baskin-Robbins ice cream shop and copyrighted by them!), there is always somebody who will sell something a little cheaper, but if you want the highest quality, expect to pay a little more for it. Tell that to potential customers when you quote a price of $25 or more for an 11″ x 14″ black-and-white portrait, and you'll win a few, lose a few. Fortunately, there are more than 3,000,000 babies born in the U.S. each year, so there are always plenty of new mothers and fathers—and grandparents!

If you specialize in indoor portraits of children, you can do all your work on location, in each child's home, or you can set up a small temporary or permanent studio in your house or apartment. Certainly, the latter is more convenient, and because you eliminate travel and setting-up time, each hour can be more productive and more profitable. However, if it's inconvenient to establish a studio at home, or if zoning regulations discourage it, it's still possible to do good work and make good money photographing children in *their* homes. But allow enough time—perhaps an hour—to do the job right.

Whichever way you work, the best choice of camera is a reflex— either a single-lens reflex such as an Olympus OM-2 or a Hasselblad, or

This informal portrait was taken in my living room, with my Rolleiflex resting on the floor, using available light.

a twin-lens reflex such as a Rolleiflex. (The Rollei may no longer be "in style," but mine has served me faithfully since 1952, and I like the relatively large 2¼″ x 2¼″ negatives. I must admit, though, that I wish it had interchangeable lenses.)

You can shoot beautiful formal or candid portraits if there's enough available light. If not, use floodlamps (500w, 3200k bulbs) and bounce the light. Speedlights can also be used, either for bounce or direct light; if the latter, you'll need three or four units for the main light, side or back lights, and possibly background light.

When you're first starting out, it might be wise to stick to black-and-white film (because of the lower cost and greater exposure latitude), but after you become proficient consider offering color prints, too, made from color negatives (not slides).

Because the purpose of this book is to point out various *ways* to make money in photography—not to detail step-by-step techniques—permit me to refer you to several excellent books on the subject. One of the newest and best is *Child Photography Simplified* by Suzanne Szasz. Another good one is *Child Photography* by Bernard Fearnley. Kodak's recent book *Picturing People* by Don Nibbelink, has a very helpful section on baby and child photography, complete with photos of the photographer at work. Then there is *Photographing Children*, part of the *Life Library of Photography*. Finally, try to locate a copy of either of Josef A. Schneider's fascinating (but out of print) books, *Child Photography the Modern Way* and *Child Photography Made Easy*.

If you shoot in black-and-white and do your own processing, take the time and effort to turn out the absolutely best work you know how. Child portraits are proudly shown to every friend, relative, and stranger the parents come into contact with, and if your work is outstanding, you'll get all the business you can handle without advertising. If you lack the time, equipment, or ability to do your own darkroom work, find a good custom lab, or maybe someone at the local camera club can do the work for you at modest cost.

If you shoot in color, send all your work out to a custom lab. If there are no good labs in your area, check the ads in *Studio Photography, The Rangefinger, Popular Photography,* or *Modern Photography* magazine. A three-page ad for Interstate Color Lab (Box 246, South Bend, IN 46634), for example, offered a complete range of color processing services—film developing, prints in all sizes, enlargements on genuine canvas complete with frame, prints on Masonite offset from a pine plaque, and so on. Try a few labs before settling on one, so you can compare quality of workmanship as well as price. Make a profit on the lab work (perhaps 50–100 per cent of your cost on large prints, 100–300 per cent on small prints) in addition to your basic charge for the photography (with proofs). Offer a package deal; for example, a flat price for a 16″ x 20″, an 11″ x 14″, and two 5″ x 7″ prints, mounted or

Babies and pre-school youngsters are popular subjects for magazine covers, and it's even possible to sell black-and-white photos (to a few markets). This shot was taken with a Rolleiflex, using three lights.

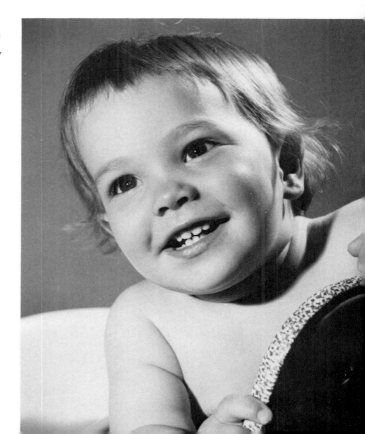

framed. Once you decide on your prices, have a price list printed up to avoid misunderstandings later on.

As I mentioned in the chapter on outdoor portraits of children, start out by photographing the children of friends and neighbors in order to build a portfolio of samples, and try to arrange for free displays in your area.

If your work is good—and keep at it until it *is* good—you should be able to average $25 an hour profit photographing children indoors, maybe more!

Babies can be photographed almost anywhere. This bathtub shot was taken with a Miniature Speed Graphic and three flashbulbs.

20
Aerial Photography

If you're afraid of heights, you can skip this chapter. Being up in a small airplane with one propeller and an open doorway, 1,000 or more feet above the ground, is no job for an acrophobiac—especially when you're spending $20 or more per hour for the plane!

However, if height holds few fears, or if holding onto a camera makes you feel braver, consider aerial photography as a source of extra income. First, though, check the *Yellow Pages* to see how much competition there is already. The Chicago phone book, for example, lists two dozen firms under "Photographers—Aerial," and many of those under "Photographers—Commercial" also offer the service.

The large, well-equipped companies in this field do the photography for mosaics, tax mapping and "volumetric computations" (according to one *Yellow Pages* ad), but even if you're a one-man enterprise with an ordinary camera you can make money in a number of ways.

For instance, you can take photos of homes—especially high-priced homes and estates—and sell them to the owners. In most cases you'd be selling a framed 11″ x 14″ or larger color print, so a color negative film such as Vericolor or Kodacolor would be recommended. Photos mounted on wood plaques or on canvas are also popular. (A firm called Guardian Professional, at 43043 W. Nine Mile Road, Northville, MI 48167, will do this in sizes up to 20″ x 24″.)

Real estate developers and industrial firms often order photo murals of their properties to use in their offices or in display booths at trade shows. These may be in black-and-white or in color, and there are a number of labs in major cities that will make the blowups for you at moderate cost, when provided with a decent negative or slide.

For example, Meisel (Box 6067, Dallas, Texas 75281) will make a 40″ x 60″ color print for $165.00, plus $26.25 for mounting on Masonite and $2.50 for spraying (1976 prices). A second print from the same negative is about $46.00 cheaper. Larger prints are $11.00 per square

foot for the first, and $8.35 per square foot for each additional. If you supply a slide, add $12.00 for an 8″ x 10″ internegative.

Gamma Photo Labs (314 W. Superior, Chicago, IL 60610) will make a 50″ x 100″ black-and-white mural for $63.65, plus about $58.00 for mounting on ½-inch Homosote (1976 prices). For larger murals—made in sections—figure around $2.45 per square foot.

Since shipping is a problem and an additional expense, look for a lab near you before ordering by mail.

Murals—whether in color or black-and-white—are impressive, and you can add a markup to the lab's price in addition to your price for the photography. Then, after the mural is installed, be sure to take a photo of it (include a person or two to indicate the mural's size) for showing to potential customers.

Polaroid Corporation's color negative facility at New Bedford was photographed by Aerial Photos of New England, Inc. Major corporations often need aerial photos of their facilities.

Construction companies—especially the large ones engaged in massive projects—are also potential customers not only for murals but for normal-size black-and-white or color enlargements, color slides, or sometimes motion pictures. They often want photos of a site before any work is started, progress shots taken at regular intervals, and then photos of the finished job. These pictures are used for engineering studies, publicity, and to help them get new business later on.

Scenic shots from the air are often used on advertising postcards and in brochures, and—depending on the subject—may sell to encyclopedias, travel books, or magazines. Some national advertising campaigns require aerial photographs, as do public relation campaigns. Government agencies use aerials for legal evidence and for traffic studies; fire departments use them to study the deployment and utilization of equipment and personnel; yacht photographers often take to the air for spectacular views; and sports photographers sometimes go aloft to cover a race on land or sea or a football bowl game.

Only an aerial photograph could show a scene like this: five jumbo jets being loaded simultaneously, with a sixth ready for takeoff. Photo taken by a United Airlines photographer.

There are still more potential customers for the photographer with access to an airplane: picture editors of newspapers (when a spectacular fire or other news event occurs); car dealers with outdoor lots, trailer parks, and other businesses wanting an aerial view of their premises; real estate firms handling commercial property (so potential buyers can see how close it is to highways, waterways, etc.); architects; surveyors; shopping center speculators; oil companies (considering service station locations); banks; and farm equipment manufacturers.

Sounds interesting? It is, and you can get started with an ordinary camera, as long as it can take sharp pictures and has a shutter speed of 1/250 sec. or faster. You do not need a special aerial camera unless you need a large negative or are shooting verticals (the camera is aimed straight down) from a height of 5,000 feet or more. All or almost all of your photos will probably be obliques (the camera is aimed at an angle) so that the relative height of different structures can be seen, and you'll be shooting from about 500 feet up (when over open water or a sparsely populated area), or 1,000 feet up (when over congested areas), or slightly higher.

If you don't plan on producing murals, you can use a 35mm camera loaded with either color negative film or a fine-grained, black-and-white film such as Plus-X. For low-level shots, the normal 50mm lens will do, but higher up you'll probably need a short telephoto. However, if there's a chance your customers may want huge prints, you're better off with a larger camera—something in the 2¼" size like the Rapid Omega, Mamiya Universal Press, Hasselblad, Bronica, or Pentax 6 x 7. If you think you'll need 4" x 5" negatives, Peter Gowland's Gowland Camera Company (609 Hightree Rd., Santa Monica, CA 90402) offers a 4" x 5" aerial camera at a very modest price. (They also have a 5" x 7" aerial for not much more.)

Before going up to take aerial photos, you should know something about subject contrast, filters, aviation forecasts, selecting aircraft, aviation safety, exposure, and coping with haze. These and other topics are covered in Kodak's booklet, *Photography from Light Planes and Helicopters* ($1.50). For more details on shooting and selling aerial photos, send $10.25 to Plan-A-Flight Publications, Box 7014, Nampa, ID 83651, for a copy of *Gold Mine in the Sky,* a small but detail-packed book by George R. Crowe. Among other things, he reveals how to rent a plane with a pilot for the least amount of money, and how to sell your aerial shots before or after you take them.

One last suggestion: be certain that your life insurance policy is in force and that it covers you when flying in private planes with commercial or non-commercial pilots. And—just in case—bring along an air-sickness bag!

Index